CLAES OLDENBURG DRAWINGS
in the Whitney Museum of American Art

CLAES OLDENBURG
DRAWINGS, 1959–1977

CLAES OLDENBURG with COOSJE VAN BRUGGEN
DRAWINGS, 1992–1998

in the Whitney Museum of American Art

Janie C. Lee

Whitney Museum of American Art, New York
Distributed by Harry N. Abrams, Inc., New York

This book was published on the occasion of the exhibition *Claes Oldenburg Drawings in the Whitney Museum of American Art*, at the Whitney Museum of American Art, New York, June 7–September 15, 2002.

Research for Museum publications is supported by an endowment established by
The Andrew W. Mellon Foundation and other generous donors.

A portion of the proceeds from the sale of this book benefits the Whitney Museum of American Art
and its programs.

Front cover: Claes Oldenburg and Coosje van Bruggen, *Soft Shuttlecocks, Falling, Number Two*, 1995 (pl. 91)
Frontispiece: Claes Oldenburg working on *Study of a Swedish Bread—"Knäckebröd"*, Moderna Museet,
Stockholm, 1966. Photograph by Hans Hammarskjöld
Back cover: Claes Oldenburg, *Study for a Soft Sculpture in the Form of a Giant Lipstick*, 1967 (pl. 48)

Library of Congress Cataloging-in-Publication Data

Lee, Janie C.
 Claes Oldenburg drawings in the Whitney Museum of American Art / Janie C. Lee.
 p. cm.
 ISBN 0-8109-6833-9
 1. Oldenburg, Claes, 1929---Exhibitions. 2. Bruggen, Coosje
van--Exhibitions. 3. Artist couples--United States--Exhibitions. 4.
Artistic collaboration--United States--Exhibitions. 5. Drawing--New
York (State)--New York--Exhibitions. 6. Whitney Museum of American
Art--Exhibitions. I. Title: Claes Oldenburg and Coosje van Bruggen. II.
Oldenburg, Claes, 1929- III. Bruggen, Coosje van. IV. Whitney Museum of
American Art. V. Title.
 NC139.O457 A4 2002
 741'.092'273--dc21

 2001008046

Distributed in 2002 by

 Harry N. Abrams, Inc.
100 Fifth Avenue
New York, N.Y. 10011
www.abramsbooks.com

Abrams is a subsidiary of

 LA MARTINIÈRE
 GROUPE

Printed in Germany

CONTENTS

One of the Whitney Museum's primary responsibilities is to expose younger artists and audiences of all ages to the great art of America's recent past. No one could be more deserving of such exposure than Claes Oldenburg and Coosje van Bruggen. And no form of display could be more celebratory than the presentation of a major recent acquisition. In one step, the Whitney has become the primary repository for the graphic work of this remarkable pair of artists.

That acquisition is the result of a sonorous triangulation among the artists, the curator Janie C. Lee, and the Whitney's ever-generous chairman, Leonard A. Lauder. All of America is the beneficiary of his extraordinary generosity and that of the artists. We are now in the enviable position of being able to enlighten future generations about the critical component of Oldenburg's and van Bruggen's creative process: the idea expressed in drawing. Anyone who has sampled the sculptural realization of their ideas is already smitten. But through the benefit of having the primary stage of artistic innovation in one place, we all stand to learn more about this fountain of creativity that has for decades enriched American culture and that of the world in general.

Janie C. Lee has been the tireless advocate of this project, and we are all in her debt as well. Her keen eye, discernment, and acute scholarship have produced a memorable result.

Leonard A. Lauder has once again shown us how a single collector and patron can reshape an institution's holdings. His continuing commitment to the Whitney's mission is admirable and serves as an example to all.

The present exhibition gives a rich and textured understanding of the work of Claes Oldenburg and Coosje van Bruggen, and we invite you to dip into their tactile, imaginative world, which is expressed through more than ninety unforgettable drawings spanning four decades.

Maxwell L. Anderson
Alice Pratt Brown Director

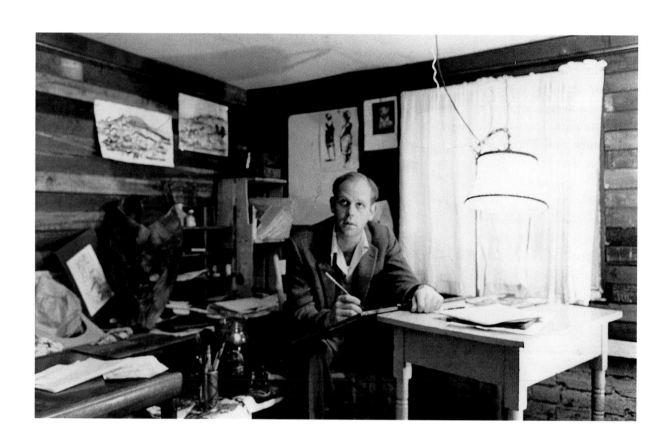

INTRODUCTION

Janie C. Lee

The drawings of Claes Oldenburg translate the unsung details of everyday existence into a language of artistic intention, a language of design. Making the familiar strange, the variations on everyday forms explored in these works suggest a secret, shared psychological life of individuals and objects and their environments. The works assembled for this exhibition of the drawings of Claes Oldenburg and Coosje van Bruggen span an entire career, from Oldenburg's sensitive early explorations of the medium to his veteran campaigns as a refined and accomplished draftsman.

For Claes Oldenburg, drawing is crucial to his art. Drawings note the beginning of an idea, they develop the thought; they express the artist's fantasies and give birth to his sculpture. Drawings serve many functions for Oldenburg, but it is the way he gently but assuredly moves his hand across the paper to express his thoughts that makes him one of history's great draftsmen.

Like his sculptural projects, Oldenburg's drawings range in size and scale, from small notebook studies to fully realized works. The notebooks constitute a diary of ideas, containing sketches and drawings that will later be realized as sculptures. The varied tools he employs, including ink, crayon, pencil, watercolor, and gouache, afford Oldenburg an astonishing flexibility of conception and expression. These activities make up the living core of his artistic practice.

Claes Thure Oldenburg was born on January 28, 1929, in Stockholm. His father was a Swedish diplomat, and the family moved between Sweden, New York, and Norway before settling in Chicago in 1936. Oldenburg studied art and literature at Yale University from 1946 to 1950. He returned to Chicago after graduation and pursued courses at The Art Institute of Chicago. In 1956 Oldenburg moved to New York and worked in the Cooper Union Library, where he had time to peruse the publications and drawings in the collection.

For the next three years, from 1956 to 1959, Oldenburg concentrated on figurative drawings in landscapes and domestic interiors. He worked with a black grease crayon to achieve an open, impressionistic style of rendering. The drawings of this period, such as *Bicycle on Ground* (1959; pl. 1), are characterized by Oldenburg's energetic gesture, immediacy of line, and concern with form in light and space, qualities that would remain integral to his developing style.

Claes Oldenburg in his studio, Oakland, California, 1953

9

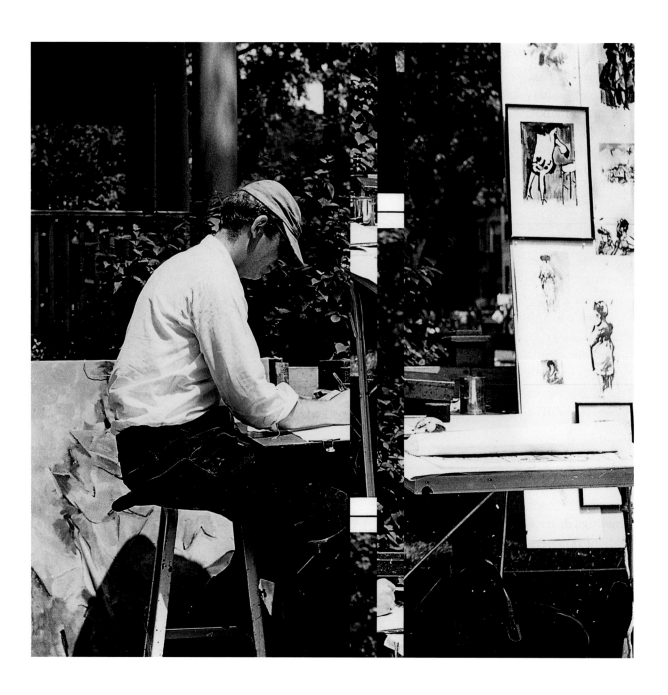

Beginning in the fall of 1956, Oldenburg moved into a studio on 12th Street, and made drawings of familiar objects. In speaking of that moment he has said, "I was very lonely, and those objects were my company; bottle caps, razor blades, my stove, ink bottle."[1] It is also at this time that the subject of Oldenburg's focus changed, and he began to devote himself to capturing the forms and textures of urban life in New York. In a group of drawings produced in 1959–60, which he called the "Street" drawings, he used pencil and crayon to document the images, actions, sounds, and thoughts that he experienced in the course of his walks through the city. These works reveal the loneliness, pain, and squalor he observed around him, in the people, the objects, and the situations that made up the life of the street. Yet at the same time he incorporates humor into his depiction of these objects and emotions.

The Ray Gun, which would become an important point of symbolic reference for Oldenburg, makes its first appearance in these drawings. The multiple associations of this object serve to connect the personal with the popular, evoking comic-book science fiction as well as phallic fantasies. Oldenburg's fusion of mass culture with private sexual or aggressive impulses anticipated the direction his work would take in years to come.

The drawing *Nude Figure with American Flag—"ABC HOORAY"* (1960; pl. 7) signaled a shift from the ragged, torturous line associated with the darkness of the "Street" drawings to rounded, colorful, more buoyant forms, as the artist left the streets behind and ventured indoors. In his next series, "The Store," Oldenburg created an environment that functioned simultaneously as artist's studio, art gallery, theater, and general store. The sculptural objects he made at this time were modeled after common foodstuffs and commodities; the "Store" drawings described these objects and how they were to be displayed for sale. The work of this period played with changes in scale and physical state. Soft objects, for example, could be drawn as though they had become hard and stiff, like the overstarched *Store Window—Yellow Shirt, Red Bow Tie* (1961; pl. 10).

A move to the West Coast and a new theme for Oldenburg's sculptural and graphic production, "The Home," led to a preoccupation with interior furnishings and architectural space. Beginning with his work on *Bedroom Ensemble* in 1963, Oldenburg's drawings show the influence of architectural blueprints and

Claes Oldenburg at the Outdoor Art Exhibition, Chicago, 1954

engineering diagrams. Just as the "Store" drawings had experimented with form and scale, the "Home" drawings investigated the expressive potential of volume and space. The line could be straight and precise, as in *Plan for a Sculpture in the Form of Wall Switches* (1964; pl. 20), or it could define shapes that are plump and voluptuous, as in *Icebox* (1963; pl. 26), illustrating the filled-out contours of his "soft" sculptures.

In 1965 Oldenburg began to draw giant-sized versions of objects placed in incongruous settings. Among the earliest examples of such drawings are *Proposed Colossal Monument for Lower East Side—Ironing Board* (pl. 32) and *Proposed Colossal Monument for Ellis Island—Shrimp* (pl. 34). As schemes for actual constructions, most of these "colossal monuments" were too fantastic or impractical to be realized. They belong to the extensive and colorful history of utopian architectural projects that were never built, from eighteenth-century French visionary architecture like that of Jean-Jacques Lequeu to Russian artist Vladimir Tatlin's *Monument to the Third International* of 1920. Their radical originality lay in their emphasis on the forms of everyday objects, the ordinary observed for its form, not its use. Removed from their functional contexts and made huge, such objects appear to hold out some mysterious message or meaning, as in a dream. Oldenburg's drawings of these objects seem like illustrations of a modern allegorical fable. Certain works, such as the drawings *Proposed Colossal Monument for Central Park North, N.Y.C.—Teddy Bear* and *Proposed Colossal Monument for Park Avenue, N.Y.C.—Good Humor Bar* (both 1965; pls. 35 and 33), exhibit a loose gestural style reminiscent of Oldenburg's early landscape drawings and watercolors. *Base of a Colossal Drainpipe Monument, Toronto, with Waterfall* (1967; pl. 42) features a tighter and more active line, which gives way to bursts of dense, energetic cross-hatching. In lyrical counterpoint, the ruled lines and precise, machined edge of the gigantic drainpipe negotiate rational form amidst a whirlwind of scribbles and dashes. The colossal monument drawings and the resulting sculptures forever changed our idea of sculpture.

Throughout his artistic career, Oldenburg has explored the resemblance of inanimate objects to parts of the human body. Around the time of his work on the colossal monuments, he produced drawings such as *Nude with Electric Plug*

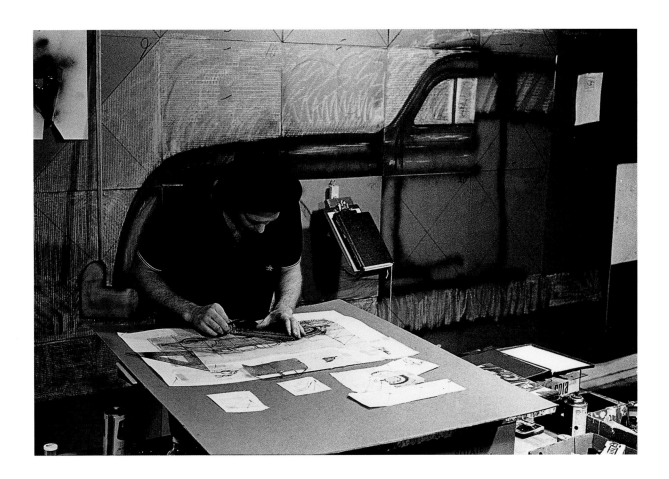

and *Drainpipe—Dream State* (both 1967; pls. 46 and 44), which evoke ideas about the most private and personal realm of bodily experience, our sexuality. The intersection of the erotic with public and political affairs became the subject of another series of drawings, begun in 1966, of a lipstick in various states of extension. In 1967 Oldenburg produced a study for a large "soft" lipstick, and in 1969 he created an actual diagram for a lipstick monument titled *Study for Feasible Monument: Lipstick, Yale* (pl. 49). This, the first of Oldenburg's "feasible" monuments, was commissioned by a committee of graduate students at Yale

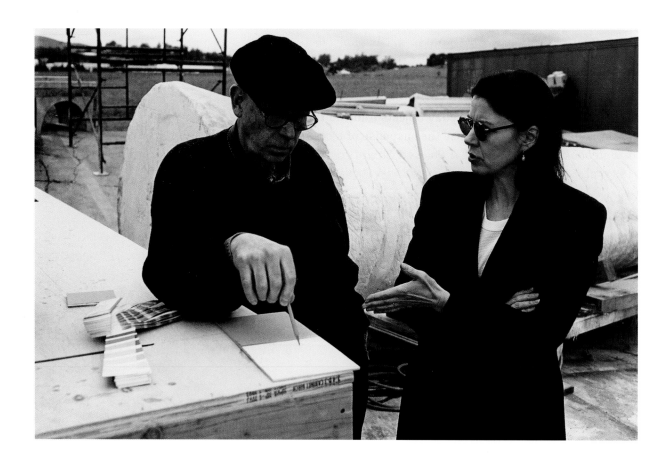

University and realized in 1969. Mounted on a base suggestive of tank treads, the lipstick was intended to be inflated on the occasion of student protests and other public gatherings.

The success of this project opened a rich vein of possibilities for large-scale public sculpture and urban monuments that Oldenburg has continued to mine ever since. In 1977 he married Coosje van Bruggen, a museum curator and writer, and a native of the Netherlands whom Oldenburg had met in Amsterdam. Linked by a shared interest in the challenges of public monumental sculpture, Oldenburg and van Bruggen have embarked on a career of close collaboration

on various outdoor projects around the world. From 1977 to 1984 they concentrated primarily on large-scale public sculpture. In 1985, with the presentation in Venice of their new Happening, the performance piece *Il Corso del Coltello*, their collaboration took a new direction. In contrast to Oldenburg's prior focus on the slow softening of everyday objects and the timelessness of monuments, recent collaborations dramatize the suspense of a scenario only partly unfolded. In *Notebook Page: Study for a Colossal Sculpture of a Woman's Legs, Running* (1994; pl. 82) and *Blueberry Pie à la Mode, Sliding down a Hill* (1996; pl. 78) an event is frozen in midcourse, inviting us to indulge in fantasies of what came before and what follows. The drawings in which Oldenburg explores his and van Bruggen's ideas for these projects place a new emphasis on action and narrative, and a return to the field of bounded, theatrical, perspectival space. They refer us to the sweeping changes that have taken place in our time, which call into question the permanence of all things, including historical values and the eternal monument.

Throughout his life Claes Oldenburg has drawn prolifically, in many manners and in every conceivable medium. His revolutionary and innovative concepts began, evolved, and metamorphosed through his drawings. Each of these works on paper is a monument to the artist's invention, which has forever changed the look of contemporary art.

Claes Oldenburg and Coosje van Bruggen working on *Inverted Collar and Tie*, William Kreysler Factory, Petaluma, California, 1994

NOTE
1. Interview with Claes Oldenburg by Janie C. Lee held at the Whitney Museum of American Art, New York, 29 May 2001.

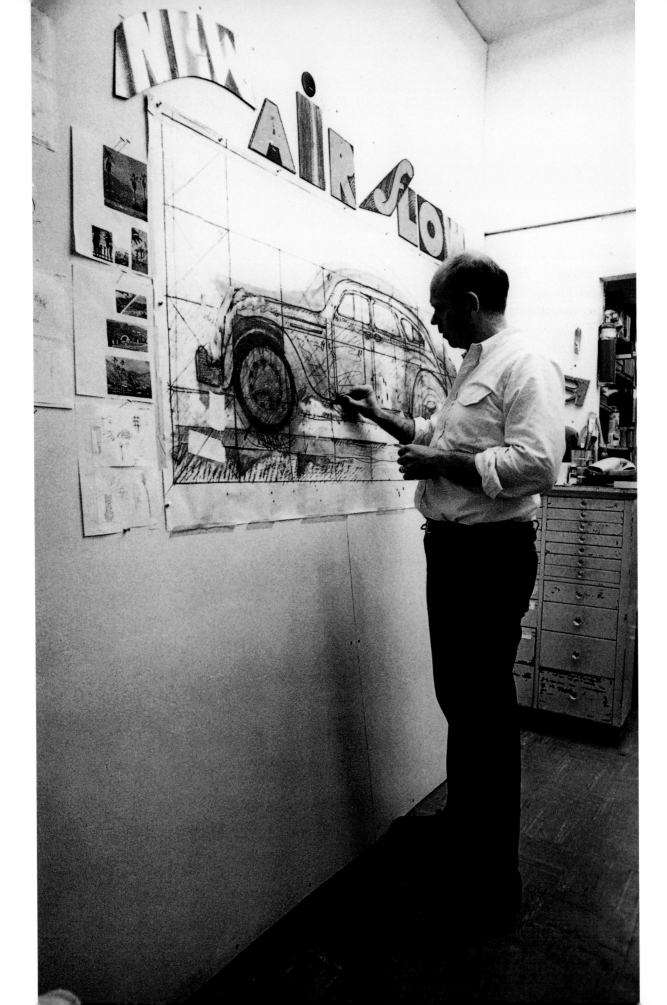

INTERVIEW WITH CLAES OLDENBURG

Janie C. Lee

Janie C. Lee: I'm sitting with Claes Oldenburg at the Whitney looking at the Museum's collection of Oldenburg drawings.[1] It is rare for a museum to be able to collect ninety-two drawings by one great draftsman. It's even rarer for the artist to be sitting in the room with those drawings, sharing his thoughts and feelings about drawing and specifically about the work we're looking at now.

The act of drawing would appear to be as natural to you as conversing or eating. In fact, I've seen you draw in your notebook while talking or dining without losing a beat of conversation. Did you teach yourself to draw your thoughts in this manner or did it just happen?

Claes Oldenburg: I've been drawing since I was very little. It's a kind of language, based in my experiences. The first serious drawings that I did had to do with an imaginary country I called "Neubern." I was about eight and our family had arrived the year before in Chicago. I did many maps of Neubern's states and cities. The country had a newspaper, and magazines and books, which I wrote for and illustrated. I also made movie posters for Neubern's Rex Studios. That's really how I started to draw, though I had been scribbling before that.

Much later, at twenty-three, I realized that the only thing I might be good at was drawing, and I decided to try and become an artist. I took a few courses at the Art Institute but mostly I spent the fifties teaching myself. I remember a landscape watercolor class at the Institute with Rudolph Pen, who took us out into the streets of Chicago where we would just sit and draw. The technique that I worked with there I still use. It is very simple, just pencil and watercolor.

I painted in oils but it didn't seem to be my medium. I was too impatient and used too much turpentine. Meanwhile, I practiced drawing constantly, in all sorts of ways, especially in places I lived which were too small to paint in.

In June 1956 I arrived by bus in New York, and eventually got a place between Avenues C and D, where I began making three-dimensional works out of stuff found on the street. My first sculpture consisted of scraps of wood nailed to a broken coatrack.

I had my first show—of poems and metamorphic objects, together with some paintings that weren't too bad—at the Judson Gallery in May 1959. I finally

17

began to feel that I might be an artist. Soon thereafter, I began publicly denying any such thing! The sixties were about to begin.

JCL: There are many definitions of drawing. You've said, "to draw is to make appear." How would you define drawing today?

CO: I think drawing is making any kind of a mark that activates a space. My particular drawing depends on line. Line is what leads it on.

JCL: The Italian phrase *disegno interno* refers to the ideal vision an artist had of a work before even beginning it. Is that the way you work? To have the idea in your head and then put it on paper?

CO: The idea must be good but how it is put down is just as important. The final image grows out of the materials, the gestures of the moment. When I start a drawing I don't know exactly what is going to happen. I know when it's right, but I don't know how to get there in advance.

JCL: Let's talk about the drawings referred to as notes. Would you think of your notes as *pensieri* or first thoughts? What is the purpose of the notes?

CO: They can be a study for something I'm working on or they can just be impulsive, something unrelated which may become a future project. An idea may strike anywhere at any time, that's why I carry a notebook. The notes are mounted and stored in scrapbooks.

JCL: When did you start giving the everyday object a new or different kind of life as a sculptural idea metamorphosing into another form?

CO: I began by trying to represent things accurately. Gradually I became interested in representing different states of mind and feelings; then gesture and material became independent. If you're true to the art process, it's by nature metamorphic.

Line especially can do anything, can be anything. Graphite is probably the medium par excellence for drawing, but I also like the greasy atmospheric lines of litho crayon. And lines can also be made by tearing paper or spilling paint.

JCL: All of your drawings from the sixties to the present have a spontaneity to them. Do you often return to a drawing and work on it or is it finished, as it were, in one sitting?

CO: *Proposed Colossal Monument for Central Park North, N.Y.C.—Teddy Bear* (1965; pl. 35) is a spontaneous drawing, done in one sitting, or standing; however, that spontaneity comes only through repetition. I do a drawing like this over and over again. This is one of maybe twenty-five drawings of the subject. It may be the best because all of the elements are put together in the right way. In a drawing like this, you have to have faith, because some of the things that happen just right are so unpredictable. And you have to accept chance, and take advantage of it.

JCL: Some drawings are done in public, like your notes or the "Street" drawings. Are there many drawings that you purposefully want or need to create alone?

CO: There's an anxiety that surrounds drawing, like any creative activity: having just the right conditions, getting around to starting up, losing your direction. The meaning of your entire life is continuously tested on every detail. All these agonies are embarrassing to exhibit, but in principle, I regard drawing as an activity to be observed, and shared. Nevertheless, some of the more extreme drawings could probably only have been done in isolation.

JCL: Looking around the room, do you see certain similar characteristics in your drawings?

CO: Yes. I can see, for example, the use of the circle in perspective. You've got the circle in perspective in the woman with the plug (*Nude with Electric Plug*, 1967; pl. 46), in the fireplug drawings (pls. 56, 57, 65–68), and with the cigarette butts

(*Two Fagends Together, I* and *II*, both 1968; pls. 63 and 62). In those the circle is extended into a column. You've got that in the drawing of the art museum too (*Museum Design Based on a Cigarette Package*, 1968; pl. 61). And the bear can be compared to the fireplug (pls. 35 and 65). You see how the fireplug is sitting the same way. And you can see the lipstick as two circles (pls. 48 and 49).

There's a consistency of geometric forms in the work, which holds it together. That has to do also with transformation. How one thing can become another. There's a kind of poetry in making comparisons that don't have any logical reason. For example, I often write such and such equals such and such. In this case I can say bear paws equals fireplug outlets. It doesn't make any sense at all, except in terms of the drawings. So it's a kind of poetry of form, going on separate from the images, in the language of the drawings.

JCL: Is that why you often work the same image so differently? As in the case of *Two Fagends Together*, where you have not only reversed the image, but changed color and medium?

CO: Yes. Once you have these forms, these simple forms, you can make variations on them. There are several motifs that go through the work like that, that bind the work together; even though the material may be different, and the approach and the circumstances may be different.

JCL: How do you distinguish a painting from a drawing, especially when you are working with enamel or gouache as in *Silver Torso with Brown Underwear* (1961; pl. 9)?

CO: Oh, I don't think a drawing has to be on paper.

JCL: But I'm talking specifically about using different mediums on paper. You still refer to them as drawings.

CO: Yes. That type of drawing was done during the painting of the "Store" pieces, using enamels which were transferred to any flat surface that happened to be

lying around. That's why they're so perishable. It usually was newspaper or something like that. I thought of them as drawings, because they're flat.

JCL: Let's look at *Material and Scissors* (1963; pl. 16), which to me has an incredible economy of line, a gentle gesture expressing both the materials and the mating of the two objects. How does this drawing relate, say, to your soft sculptures?

CO: It shows the tool and material of soft sculpture like a kind of emblem. The tool becomes what it's used on, and they become one. *Material and Scissors* happened almost by itself. I was surprised by it. Drawings sometimes have a life of their own.

JCL: The drainpipe is an object that you've explored in many mediums and metamorphoses. Here are four versions of the drainpipe (pls. 40–43), and an erotic drainpipe (*Drainpipe—Dream State,* 1967; pl. 44)—not that the others aren't. Would you talk about these different states of the drainpipe and how they evolved?

CO: They all have different functions. In 1966 there was a show in Toronto and I came up with *Proposed Colossal Monument for Toronto—Drainpipe, View from Lake* (1966; pl. 41). A drawing (*Soft Drainpipe (drawn for catalogue of* Dine—Oldenburg—Segal *group show at the Art Gallery of Ontario)*, 1966; pl. 43) [was] made for the catalogue; the three-dimensional soft-sculpture version of the drainpipe was in the exhibition. [In] *Base of a Colossal Drainpipe Monument, Toronto, with Waterfall* (1967; pl. 42), the drainpipe has a pool at the top. The water runs down through the pipe, and then out into this waterfall at the bottom. And actually, the top is also a landing strip for planes; so that you land on a hard surface over the water. People are swimming in the water, so they can look up at the planes landing on top of them and see the passengers get out.

This drawing of 1967 (*Proposed Colossal Underground Monument—Drainpipe*; pl. 40) is about an underground drainpipe. The green part is just a park, and the park consists of pure grass except at the center there's a little

hole. You look down into that hole, and you look far, far down into the earth, and into the illuminated interior of a vast underground drainpipe.

JCL: Can you also talk of the two ways you have used the word dream?

CO: *Drainpipe—Dream State* (pl. 44) may or may not be erotic in content, but the body is present in the work. And in this the body is sublimated, let's say. And here we're at a moment when the sublimated element is escaping from the obvious subject that you see.

JCL: It could also be a nightmare.

CO: It could be in the form of a nightmare, it could be a dream. The dream state of *Dream Pin* (1998; pl. 92) is less threatening. It's a dynamic situation for a garden sculpture Coosje and I were developing together, which came to her in a dream. That's why it has a double signature.

JCL: Sometimes you look at the drawings and see a dream or a sculpture emerging, or an expression of revelry.

CO: The sublimated subject can be totally exposed. Like the drawing *"Capric"— Adapted to a Monument for a Park* (1966; pl. 38) of the monumental sculpture of male genitals in place of a head, with a cap on them.

JCL: Speaking of the subject that way, let's look at *Nude with Electric Plug* (pl. 46), which to me is such an extraordinarily fantastic graphite drawing. Is this related to another image?

CO: This one, I would say, is in the category of the erotic. There's a whole group of these drawings done at the same time, about ten of them, and they are about women in relation to objects which have been used as sculptures. The plug is also adapted to earrings, you can see. But it has a kind of snoutlike look too, like a pig snout. I'm not entirely in control of the subject matter.

JCL: The colossal monument drawings are extraordinary not only because of the new sculptural ideas they present, but also as individual achievements, as some of the great fully developed finished drawings of the twentieth century.

Proposal for a Cathedral in the Form of a Colossal Faucet, Lake Union, Seattle (1972; pl. 36) skillfully combines a free-form hand with mechanical drawing, to show an everyday object made monumental and majestic with classical refinement. In fact, the drawing could define your entirely deserved reputation as one of the great draftsmen of our time. Did you do this drawing in one sitting or return to it later?

CO: This was done over a period of maybe a week, a week and a half.

JCL: Regarding the monument drawings, the poet Paul Carroll quoted you as saying, "It's been interesting to have entered the world through the door of a little Impressionist watercolor." Can you comment on this?

CO: I meant the fact that the drawings are very small in relation to the subjects they depict. And that you can make a tiny drawing of something very, very large. The feeling, when you are making a drawing like *Proposal for a Cathedral*, is that you become very small yourself. And you can imagine yourself wandering up on the hill there, or being down by the shore. You enter an imaginary universe which you have created with your pencil and watercolor. Then when you have finished it, you step back and, if you have done it right, it has an enormous scale. And then you say to yourself, it really looks like it exists. It's like a postcard. You see a postcard of someplace in a part of the world that you are never going to go to. And you believe that it exists because you've seen the picture of it. This is a very convincing representation of a thing that doesn't exist—it even has the identity of where it is, and what it is, and so on. At the top of this hill over Lake Union in Seattle, there really is an unfinished cathedral. So this is proposed for an existing structure more or less.

JCL: The imaginary on the existing.

CO: That makes it even more persuasive. The treatment is inspired by Frank Lloyd Wright's visionary drawings, which are very convincing even if they were never built.

JCL: In the seventies, eighties, and nineties, you and Coosje collaborated on a number of major monumental sculptures. In 1994, you completed one of the greatest of these, *Shuttlecocks*, for the Nelson-Atkins Museum in Kansas City. This project produced not only great drawings but great sculptures. The drawings that we have, particularly the drawing called *Soft Shuttlecock, Raised* (1994; pl. 90), is a superb example of one of your finished drawings, with its movement, the white open space, and the delicate touch of the shuttlecock alighting on the ground like a ballerina on pointe. With a drawing like that, where do you literally begin to draw the image? Do you recall?

CO: It usually begins with some sketchy overall indications of the space. Then I add as much detail as is needed, leaving quite a bit to the imagination. This particular version came after the Kansas City project. Coosje and I had been commissioned to make a sculpture to fill the rotunda of the Guggenheim in New York for the *Anthology* show. Inspired by reading about Amelia Earhart, Coosje imagined a soft shuttlecock rising and falling and related to the design of the glass ceiling above. We worked it out together on notebook pages and then did a series of drawings showing the soft shuttlecock in different positions. In this version it hangs in the center of the rotunda. In its final execution, the sculpture lay over the edge of the ramp while the feathers spread into the space. *Soft Shuttlecocks, Falling, Number Two* (1995; pl. 91) is not for a particular site. We're just playing with the subject, making soft shuttlecocks behave like real birds, or in free fall.

JCL: How would you express the change that's occurred over the past forty years in the way you actually draw? What has changed in your approach to the way that you move your hand or make your marks?

CO: In the early seventies I felt the need to put the emotionalism of the sixties

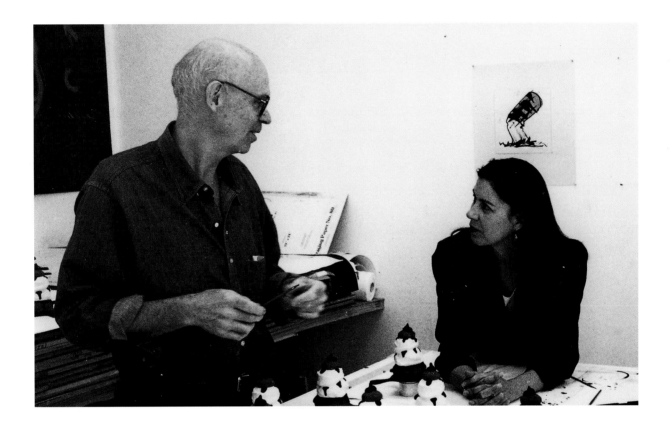

behind me and develop a precise, objective style to render images of proposals for monuments. A large part of my drawing activity in that decade had to do with printmaking. Working with Petersburg Press in London stimulated another sequence of erotic drawings, this time in ballpoint pen. At the same time, the opportunities for realizing large-scale works began, leading to technical drawings and templates. You see, it's not so much a progression as a succession of responses to different experiences and requirements.

In 1976, Coosje and I joined forces, starting a whole new period of work. We became partners in the conception as well as the production of the work, all phases, including the drawing, which would evolve out of our discussions.

Our performance in 1985 of *Il Corso del Coltello* in Venice, with its costumes,

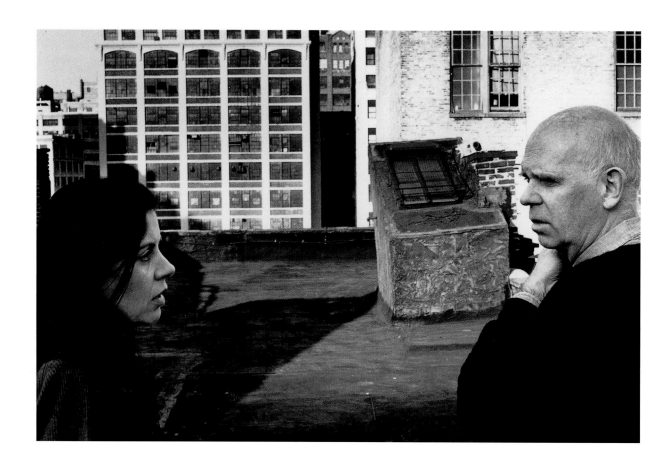

scenes, situations, characters, and props was a great stimulus. [It was] the first of a series of projects that included *Haunted House* for Museum Haus Esters in Krefeld [, Germany,] and *Entropic Library* for *Magiciens de la Terre* that were defined by drawing. At the end of the eighties, our trips to Paris to place *Buried Bicycle (Bicyclette Ensevelie)* also produced the series of perfume bottles and musical instruments, like the clarinet transformed into a bridge (pls. 73–76).

In 1991, Coosje found an old estate with a park for us near Tours in France, which inspired drawings that combine objects with nature. At Beaumont-sur-Dême, we mated a blueberry pie à la mode with the many things flying around

in the air. Then the pie became a formation of rocks and earth sliding down a hill, and after that, altering the scale, an island in itself. Coosje likes objects in motion, slightly off balance. She adds speed and acceleration to the imagery.

Even when the subjects are established ones, the unique turn of her imagery, emotive content, and far-reaching iconography give them fresh resonance. She's the real source of change and revitalization in the later works.

JCL: Claes, thank you for sharing these informative insights into the unique collaborative relationship between you and Coosje. In conclusion, I would like to go back to an earlier definition of drawing, which I think applies to the past, present, and future. In 1967, you wrote one of the greatest definitions of drawing: "To give birth to form is the only act of man that has any consequence. This act, which I call art, may take many shapes as yet undignified by that very dignified name. And in the strict sense it is drawing, which may be defined as the accidental ability to coordinate your fantasy with your hand." I've always loved that definition.

NOTE
1. Interview with Claes Oldenburg by Janie C. Lee held at the Whitney Museum of American Art, New York, 29 May 2001.

Coosje van Bruggen and Claes Oldenburg on the roof of the Broome Street studio, New York, 1989

PLATES

1. *Bicycle on Ground*, 1959

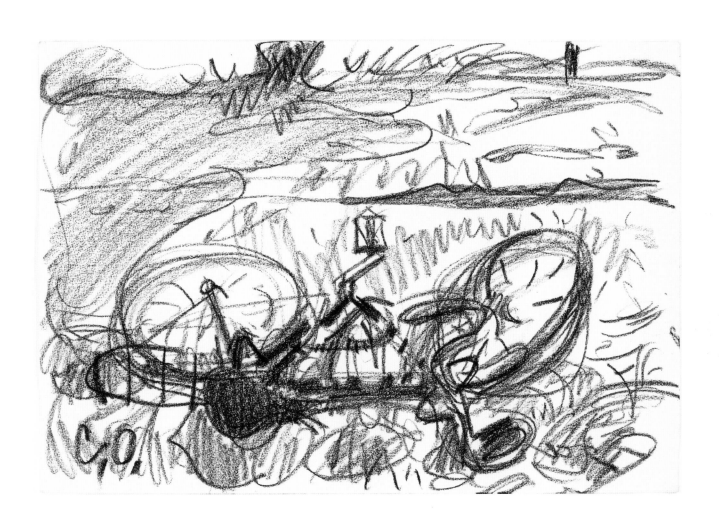

2. *Pat Reading in Bed, Lenox*, 1959

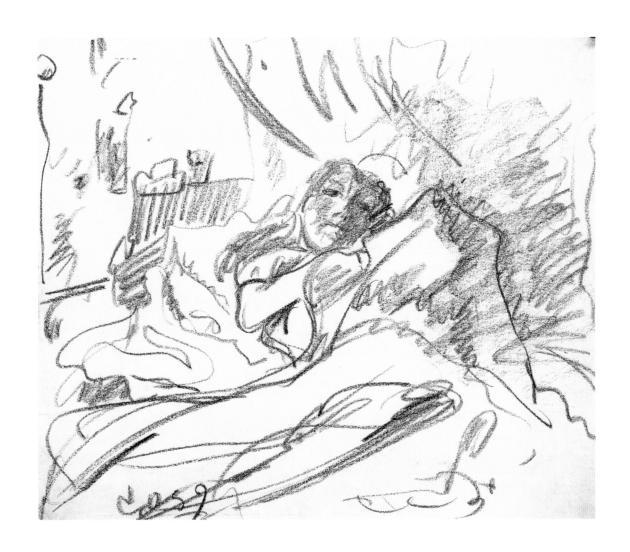

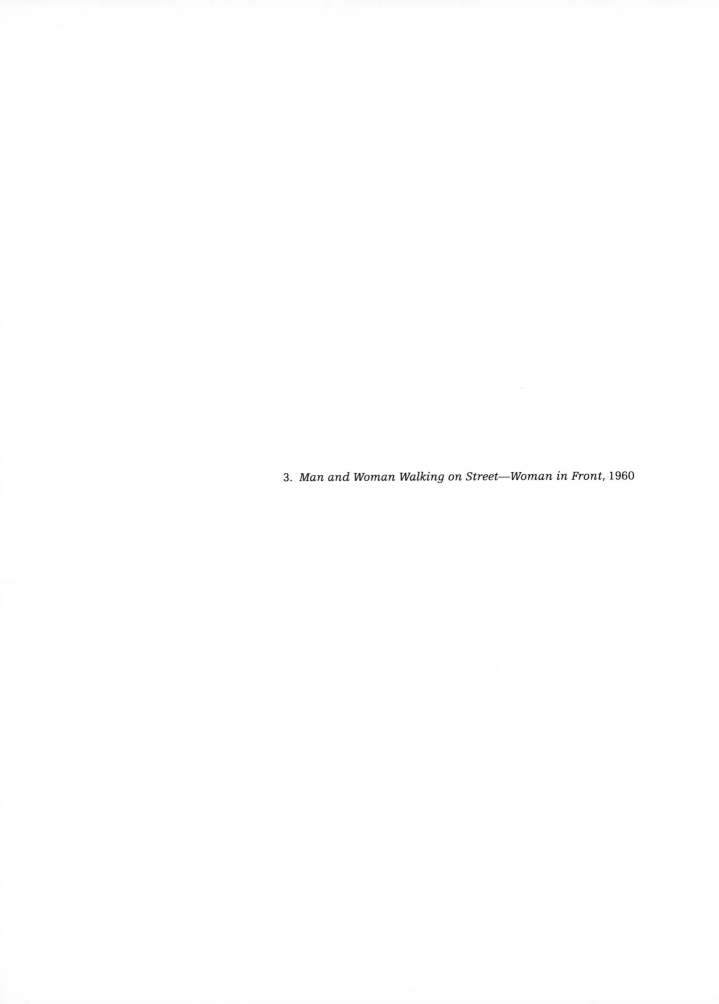

3. *Man and Woman Walking on Street—Woman in Front*, 1960

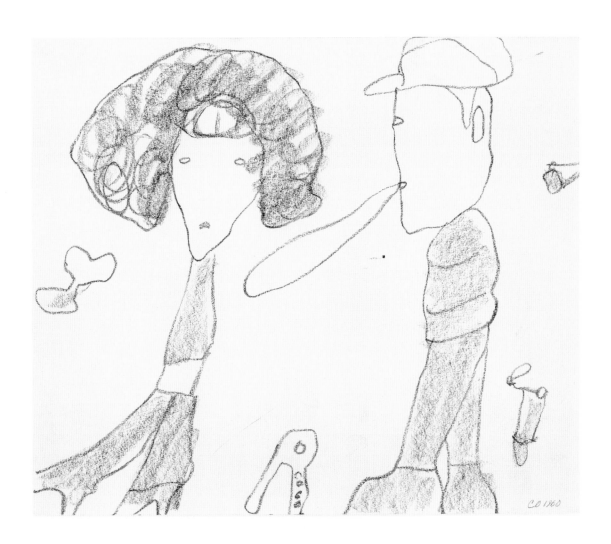

4. *Street Scene—Man, Woman, TA*, 1960

5. *Study for the Poster,* New Media—New Forms, *Martha Jackson Gallery*, 1960

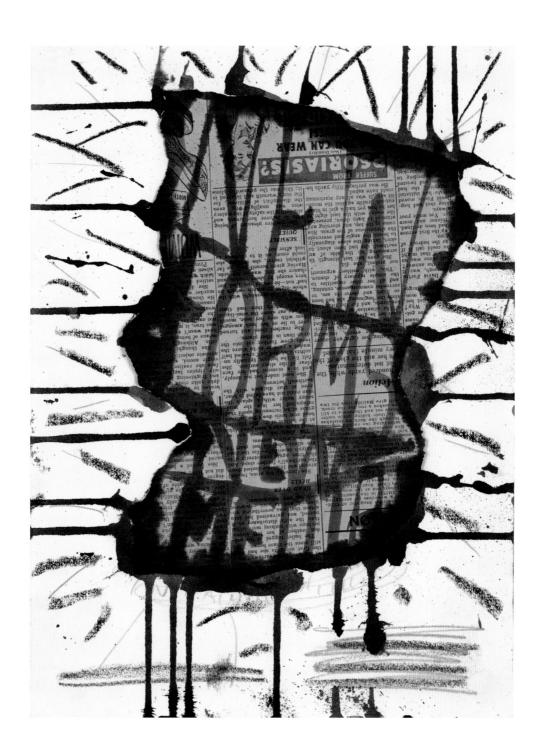

6. *Suggested Design for a Brochure Announcing* Ray Gun *Show at the Judson Gallery*, 1960

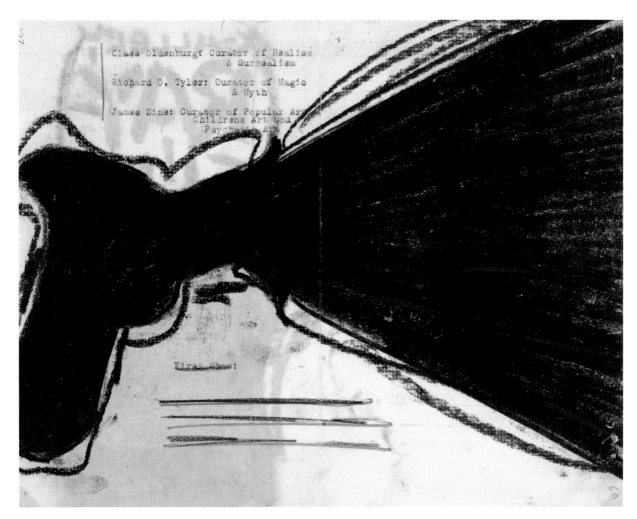

Claes Oldenburg: Curator of Realism
& Surrealism

Richard O. Tyler: Curator of Magic
& Myth

James Dine: Curator of Popular Art,
Childrens Art and
Psychotic Art

First Show:

RECTO

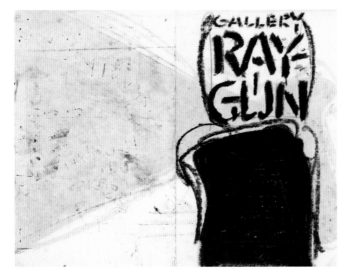

VERSO

7. *Nude Figure with American Flag—"ABC HOORAY"*, 1960

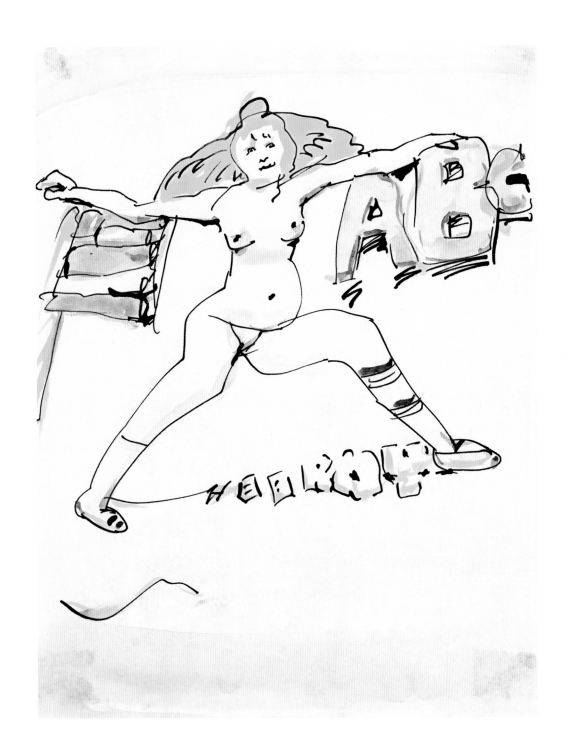

8. *Sex Act*, 1961

9. *Silver Torso with Brown Underwear*, 1961

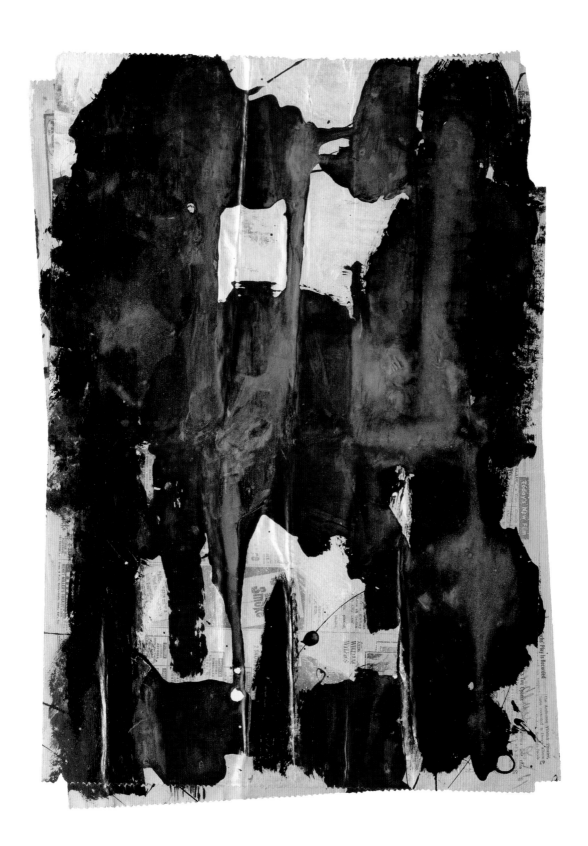

10. *Store Window—Yellow Shirt, Red Bow Tie*, 1961

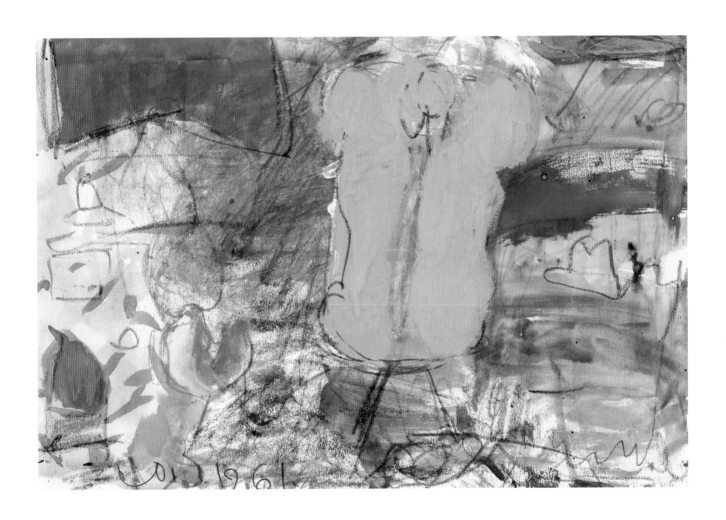

11. *Store Window—Man's Shirt, Mannekin Torso, 39—on Fragment,* 1961

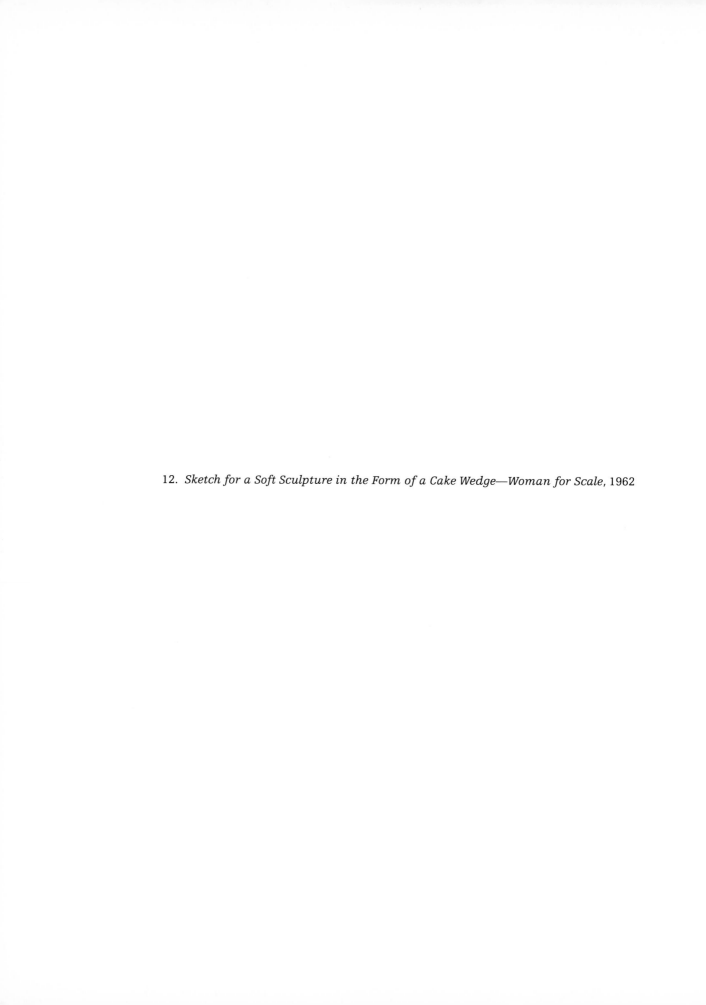

12. *Sketch for a Soft Sculpture in the Form of a Cake Wedge—Woman for Scale*, 1962

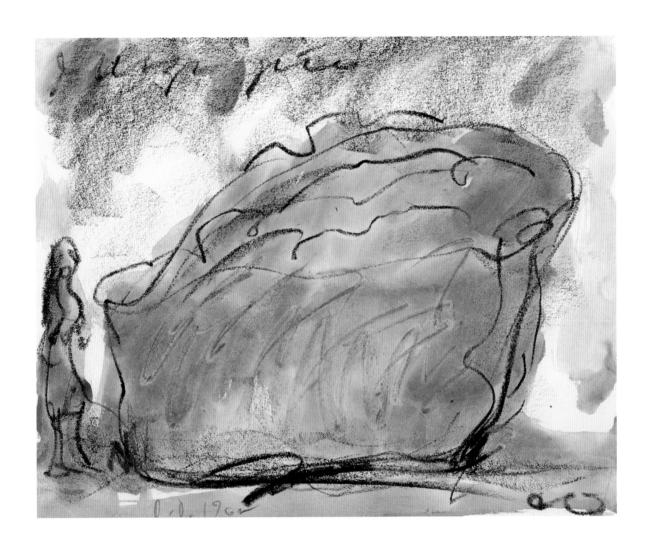

13. *Newspaper Stocking Against Newspaper Ads—"CHROMEQUEEN"*, 1962

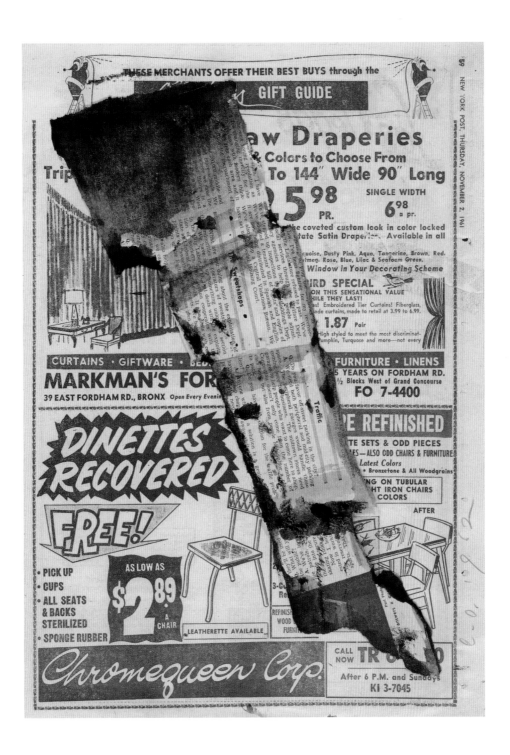

14. *Study for Announcement for One-Man Show at Dwan Gallery—*
Mickey Mouse with Red Heart, 1963

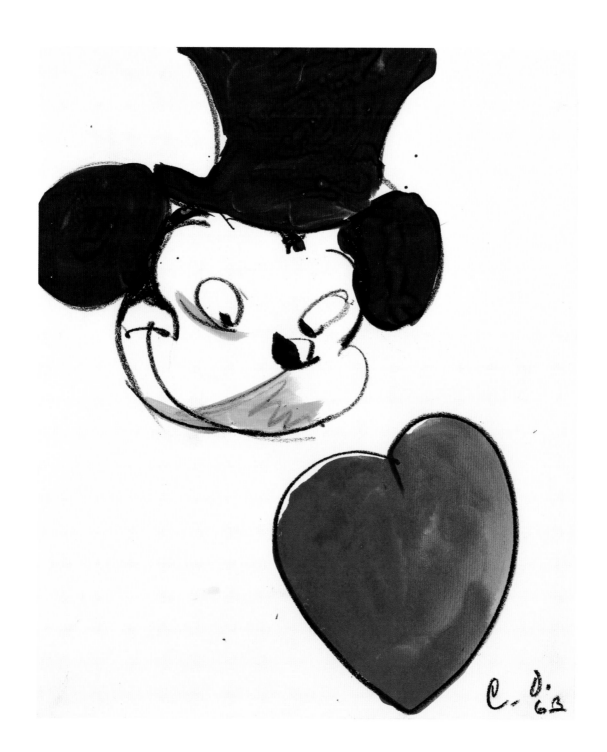

15. *Biplane*, 1963

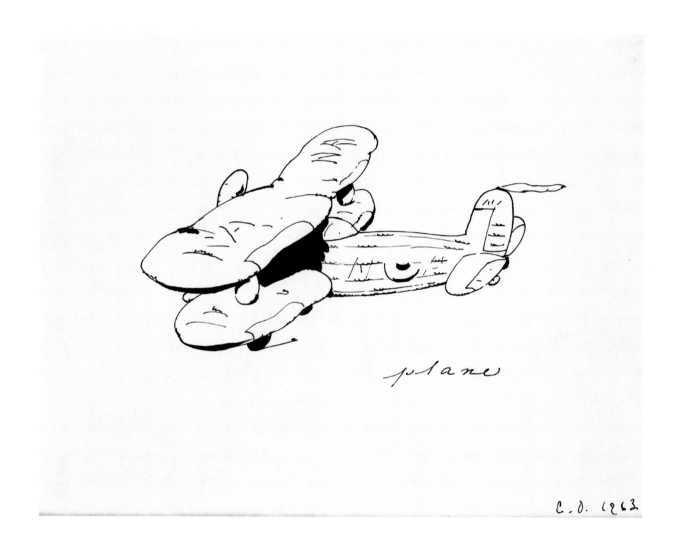

plane

C. D. 1963

16. *Material and Scissors*, 1963

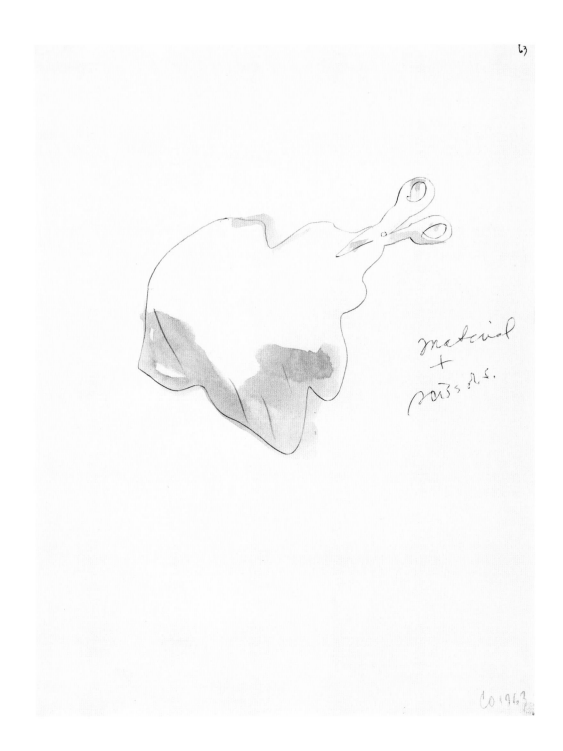

material
+
scissors.

Co 1963

17. *Study for the Poster for "4 Environments," Sidney Janis Gallery—"THE HOME"*, 1963

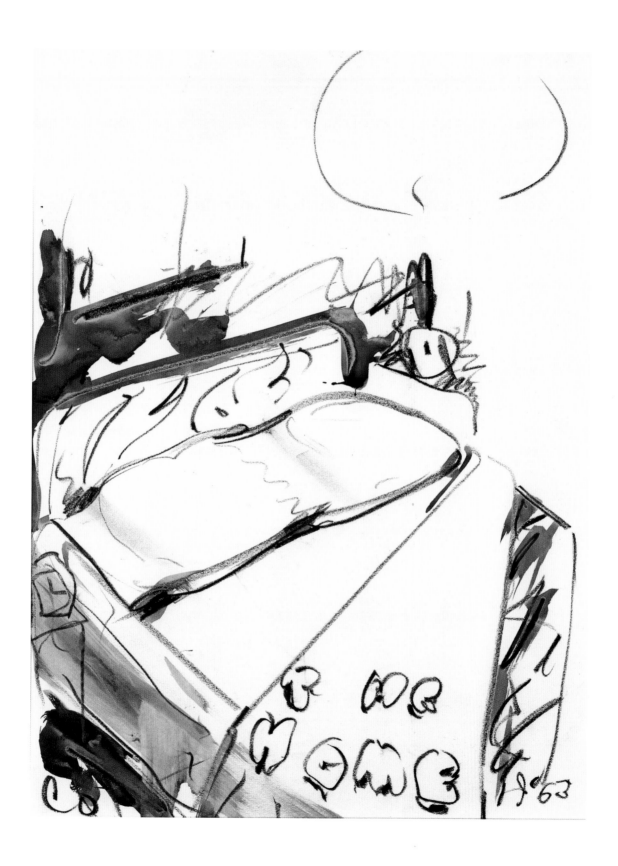

18. *Study for Zebra Chair—Bedroom Ensemble*, 1963

19. *Dressing Table*, 1963

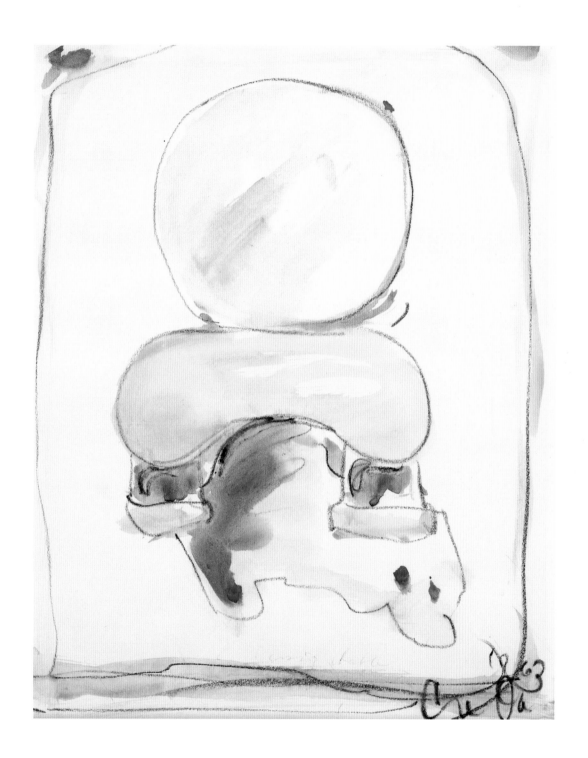

20. *Plan for a Sculpture in the Form of Wall Switches*, 1964

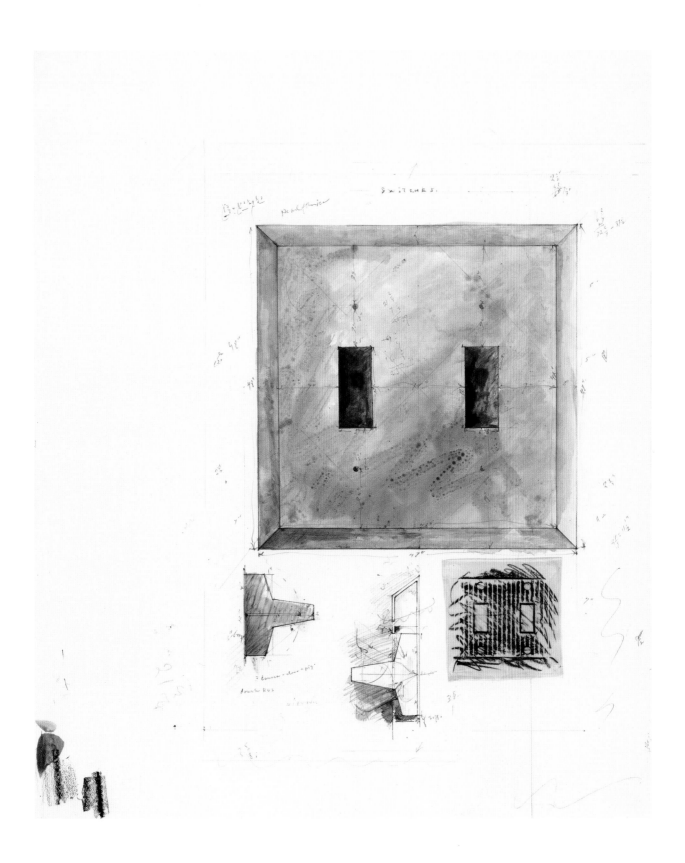

21. *Study for a Sculpture in the Form of a Vacuum Cleaner,* 1964

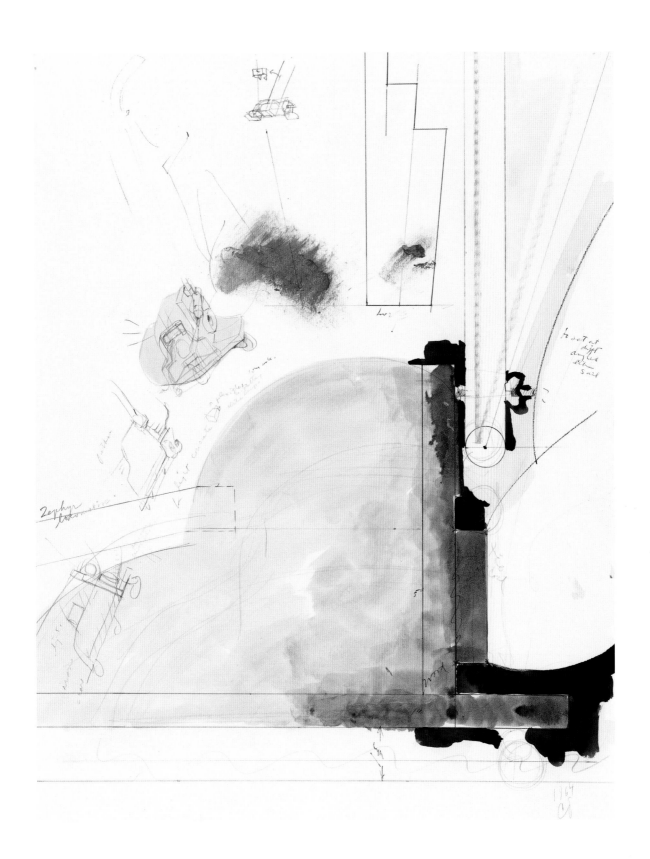

22. *A Toilet*, 1964

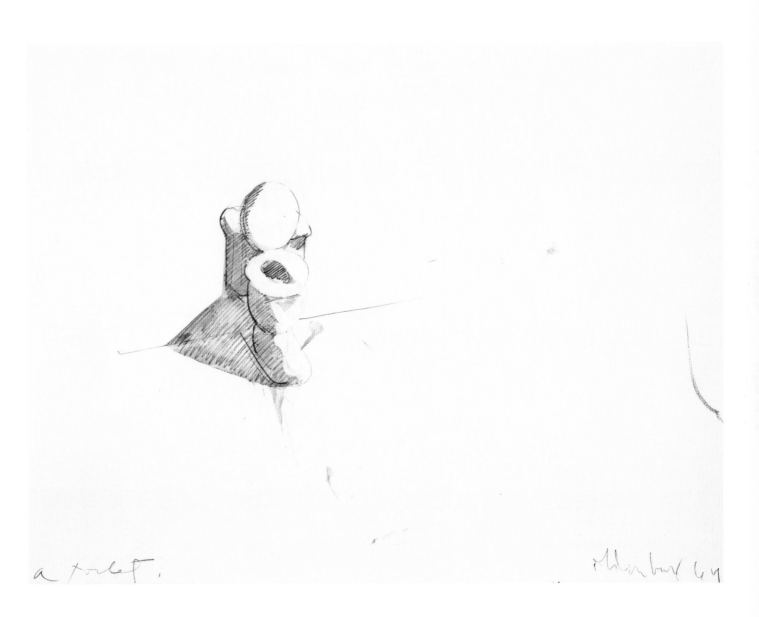

a toilet.

Oldenburg 64

23. *Sketch for a Soft Toilet*, 1965

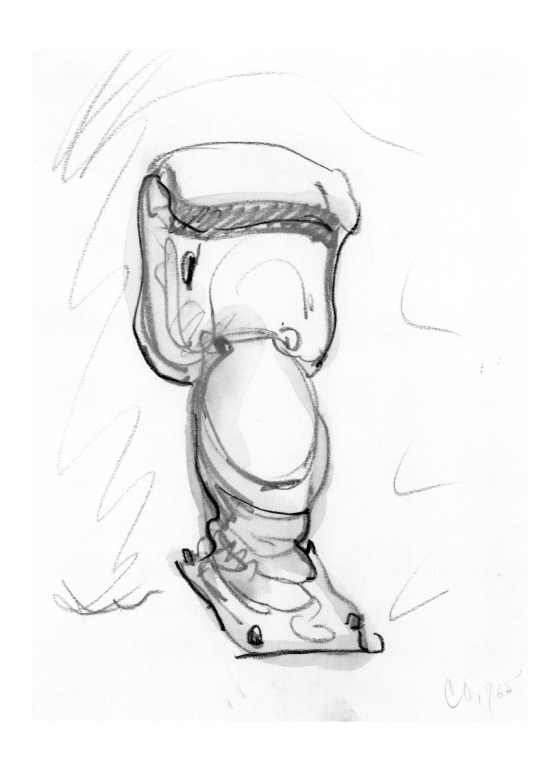

24. *Baked Potato, Thrown in Corner, under Light Bulb*, 1965

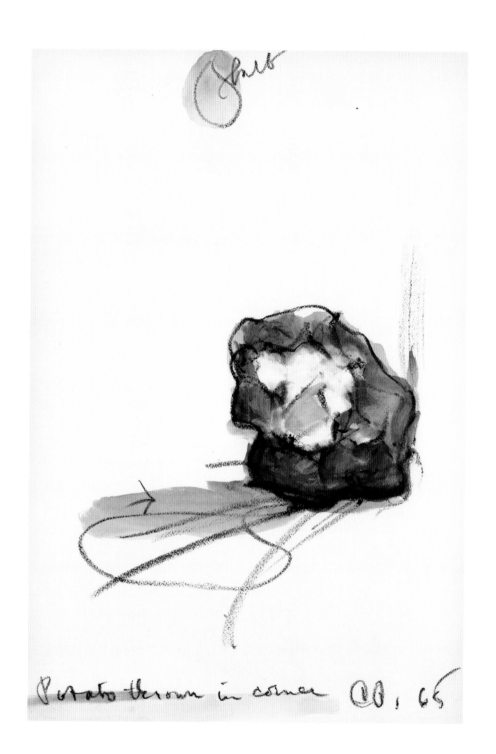

Potato thrown in corner CO, 65

25. *Ketchup, Thick and Thin—from a N.Y.C. Billboard*, 1965

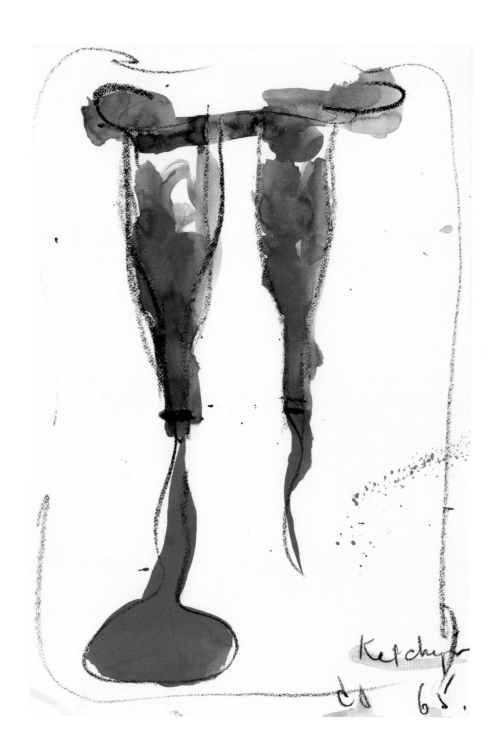

26. *Icebox*, 1963

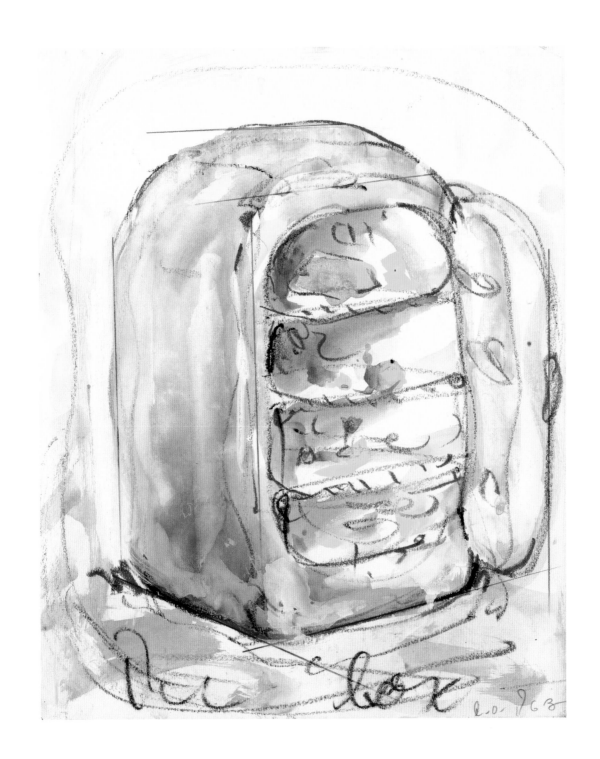

27. *Study of a Silex Juicit*, 1965

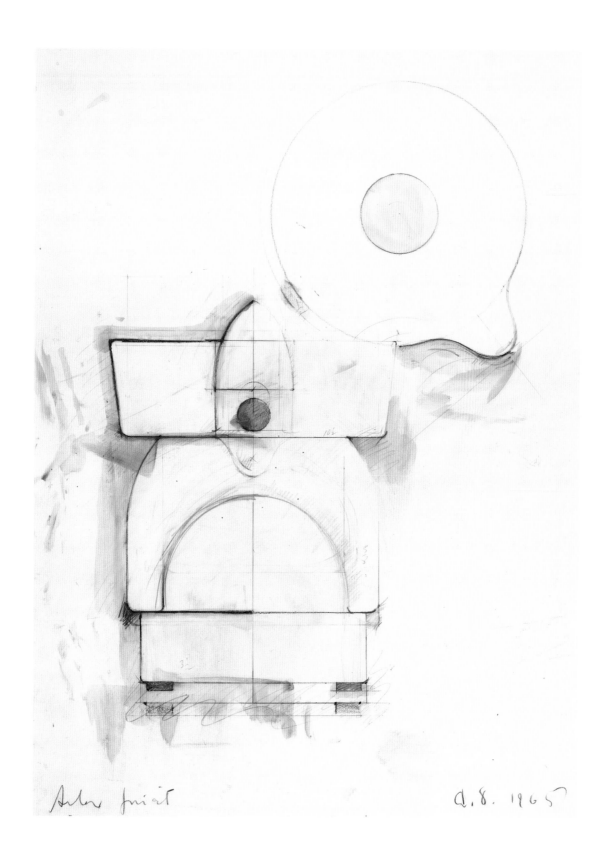

Atelier Friat a. 8. 1965

28. *Study of Fan Blades*, 1965

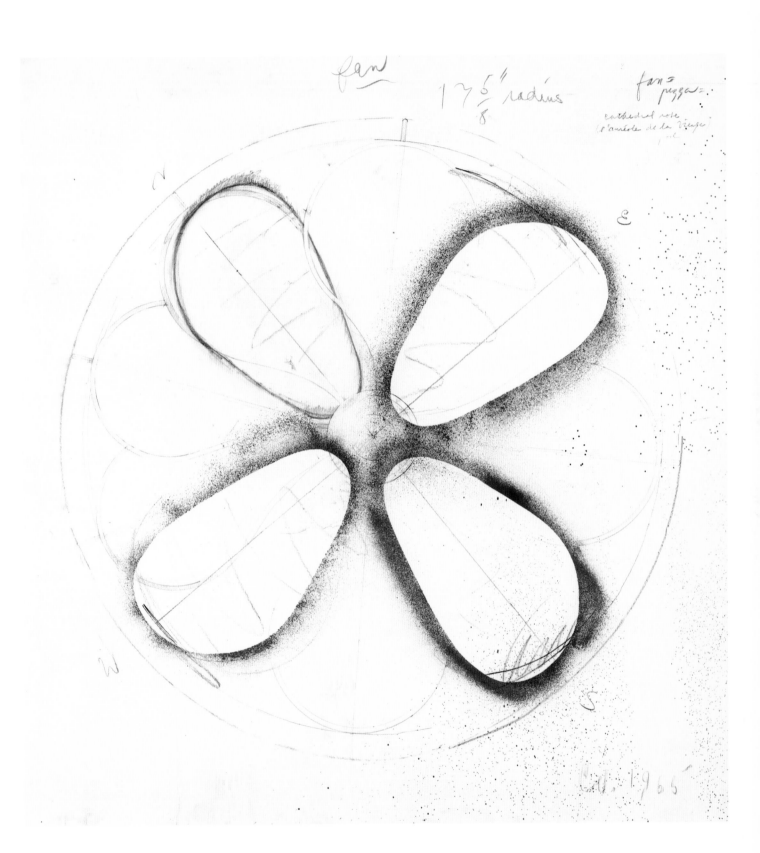

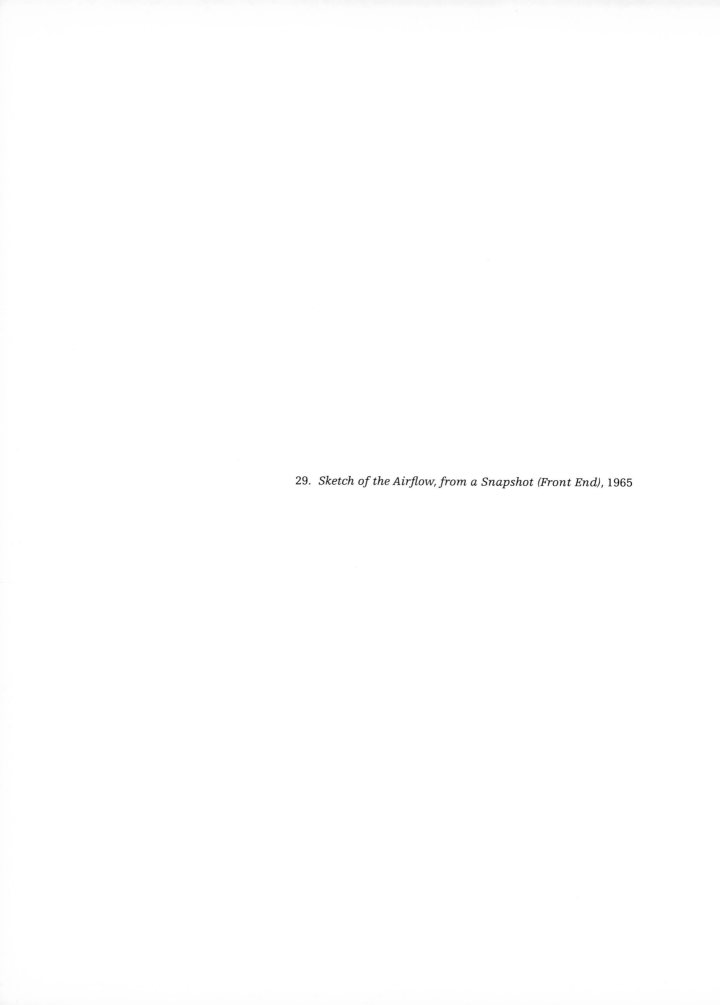

29. *Sketch of the Airflow, from a Snapshot (Front End)*, 1965

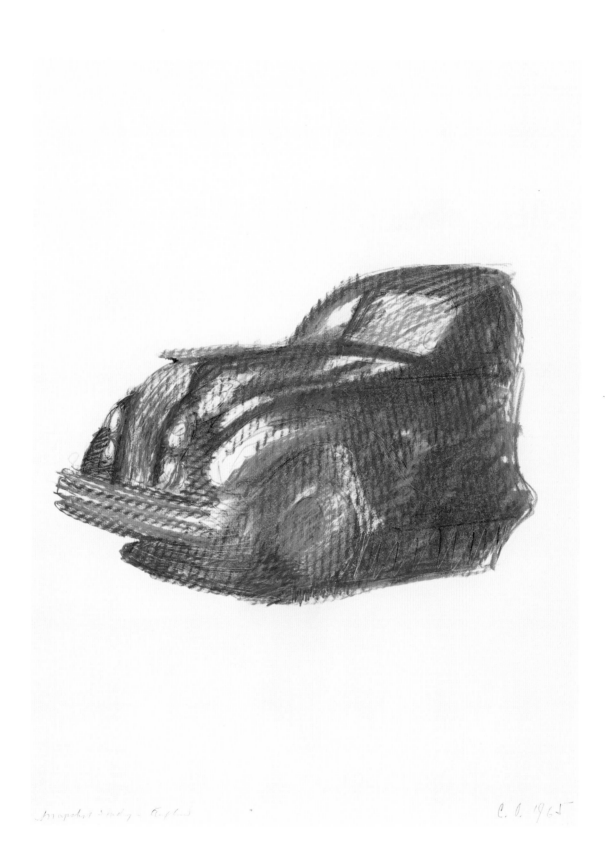

Snapshot study, Topless C. O. 1965

30. *The Airflow—Top and Bottom, Front, Back, and Sides, To Be Folded into a Box*
(Study for Cover of Art News), 1965 [mounted and re-signed 1972]

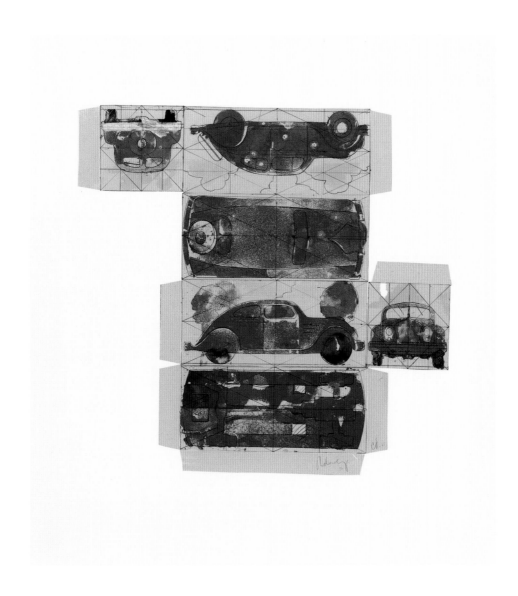

31. *Study for a Soft Sculpture in the Form of an Airflow Instrument Panel, Wheel, Gearshift, Etc.*, 1965 [signed 1967]

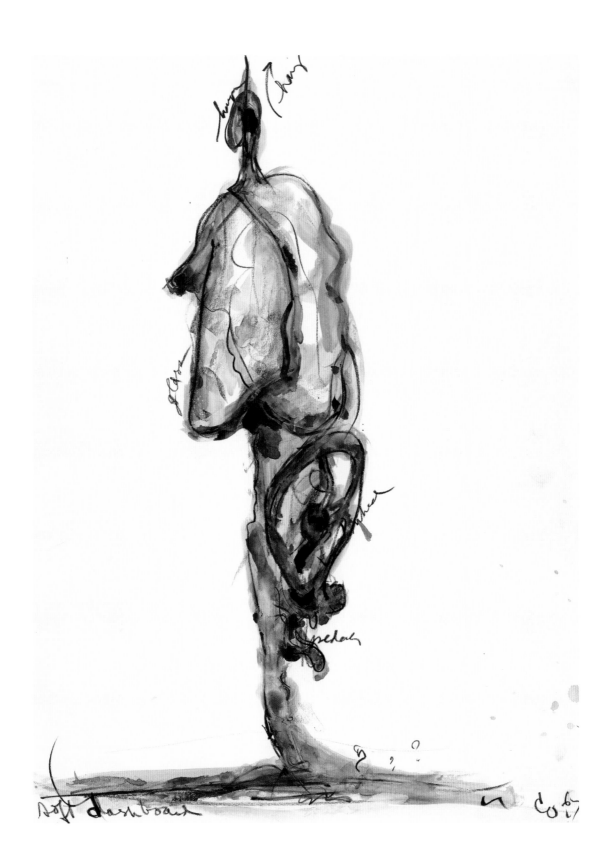

32. *Proposed Colossal Monument for Lower East Side—Ironing Board*, 1965

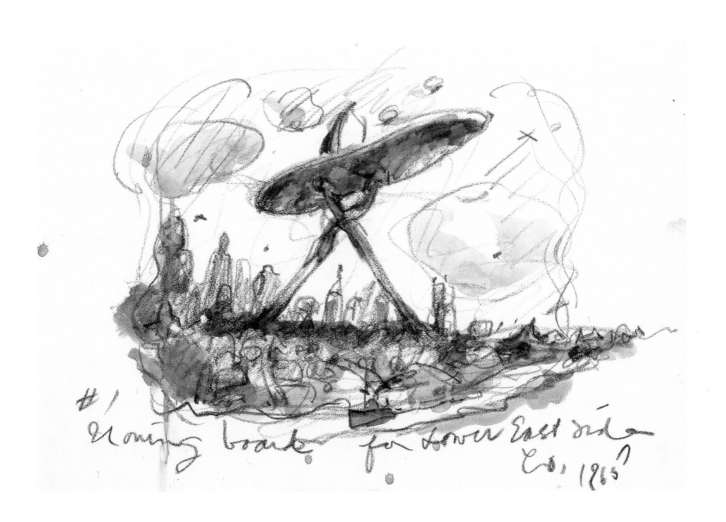

#1
flowing boat. for Lower East side
Cos, 1965?

33. *Proposed Colossal Monument for Park Avenue, N.Y.C.—Good Humor Bar*, 1965

34. *Proposed Colossal Monument for Ellis Island—Shrimp*, 1965

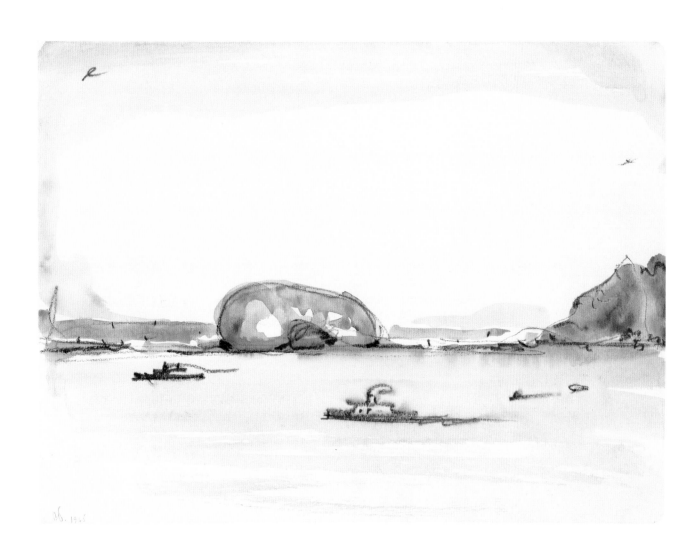

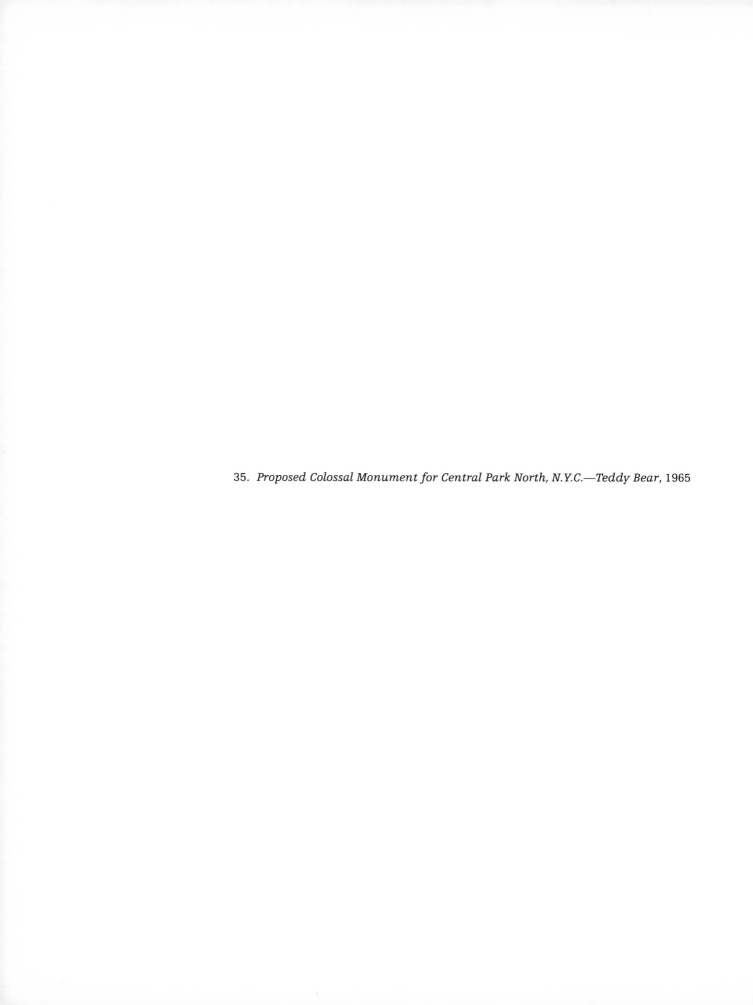

35. *Proposed Colossal Monument for Central Park North, N.Y.C.—Teddy Bear*, 1965

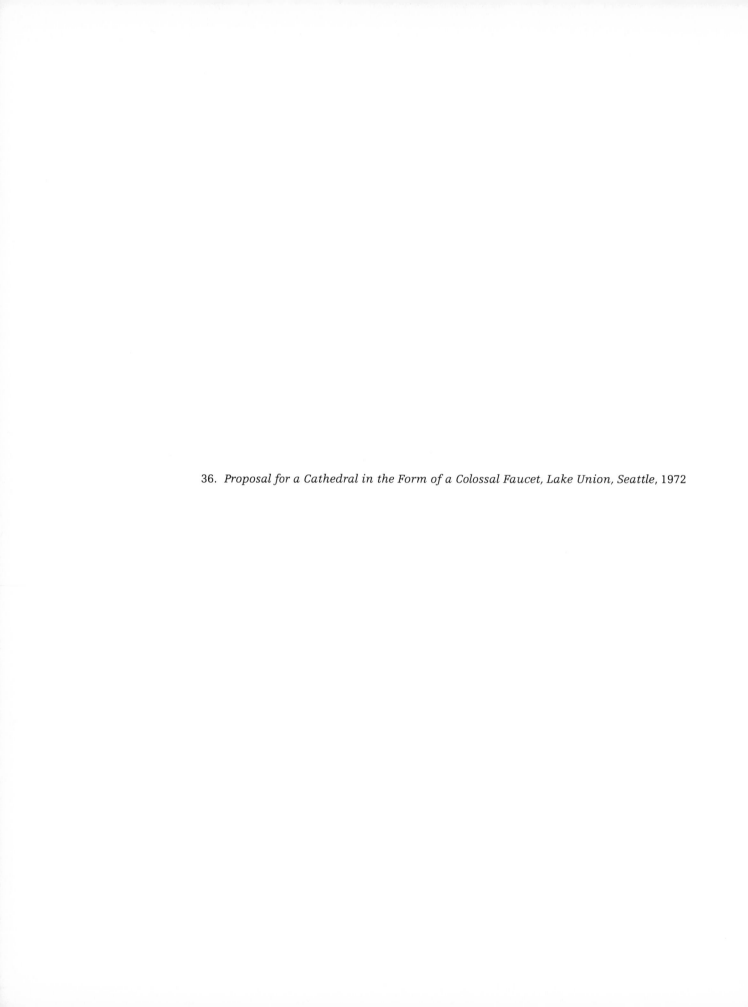

36. *Proposal for a Cathedral in the Form of a Colossal Faucet, Lake Union, Seattle*, 1972

Lake Union, Seattle, Wash. CB. 1972

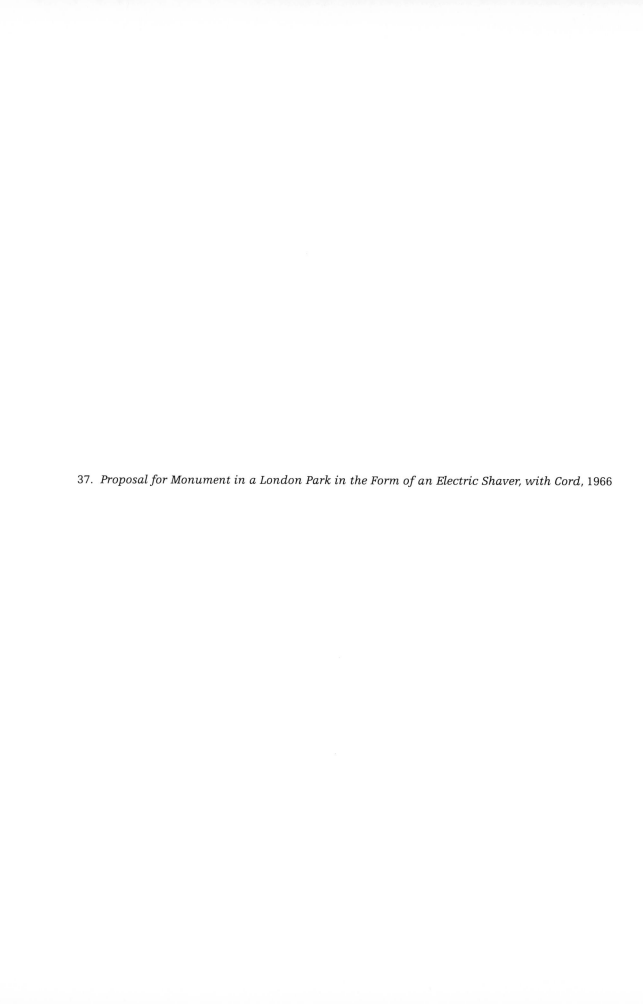

37. *Proposal for Monument in a London Park in the Form of an Electric Shaver, with Cord,* 1966

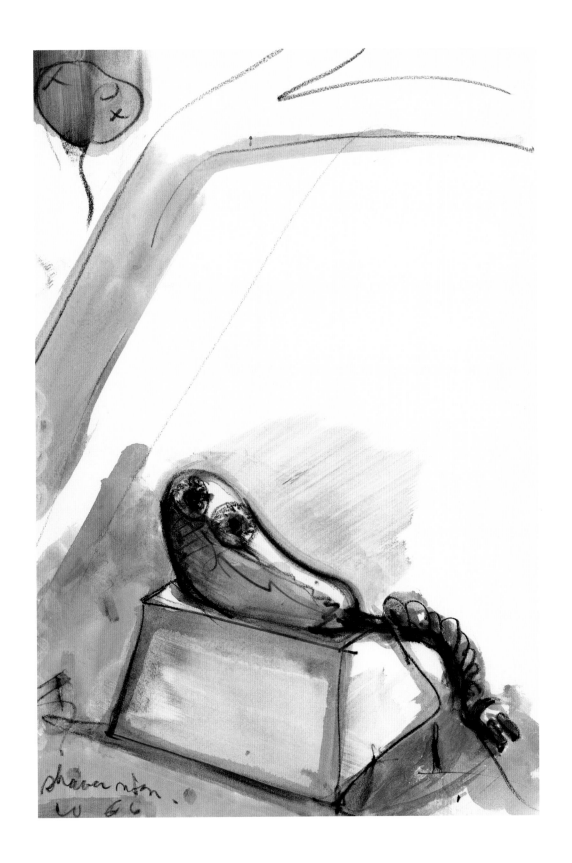

38. *"Capric"—Adapted to a Monument for a Park*, 1966

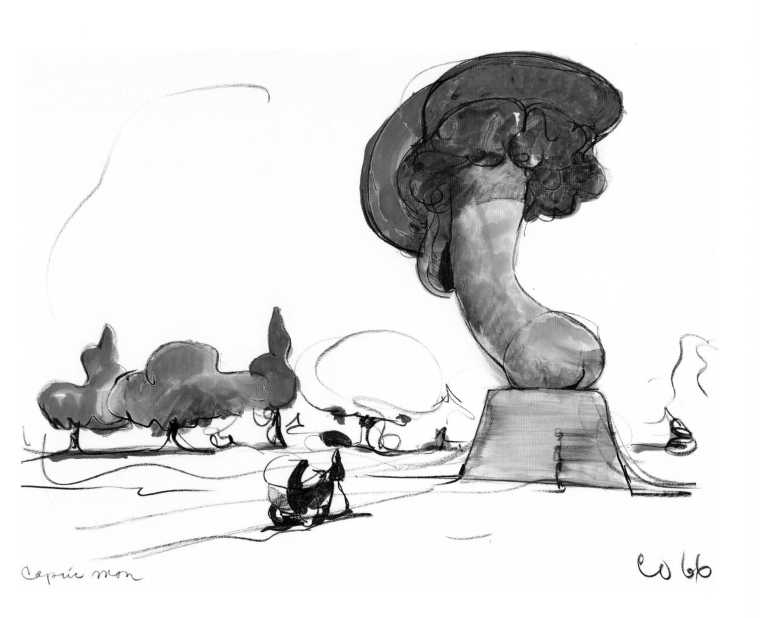

capúc mon

CO 66

39. *Banana*, 1966

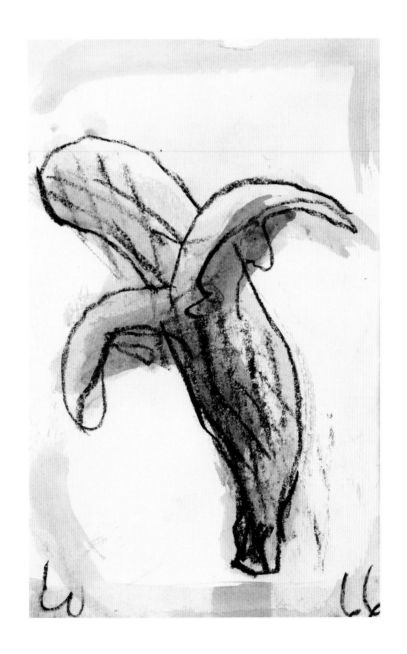

40. *Proposed Colossal Underground Monument—Drainpipe*, 1967

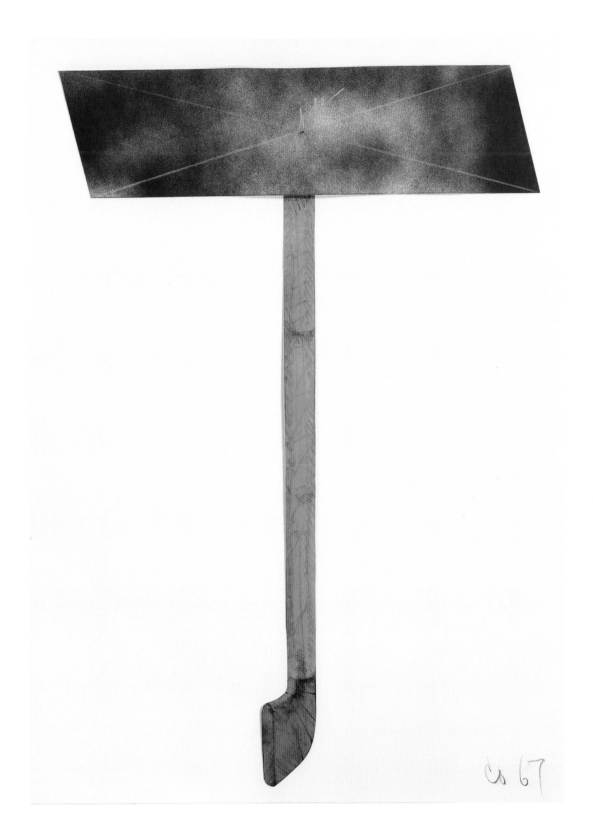

41. *Proposed Colossal Monument for Toronto—Drainpipe, View from Lake*, 1966

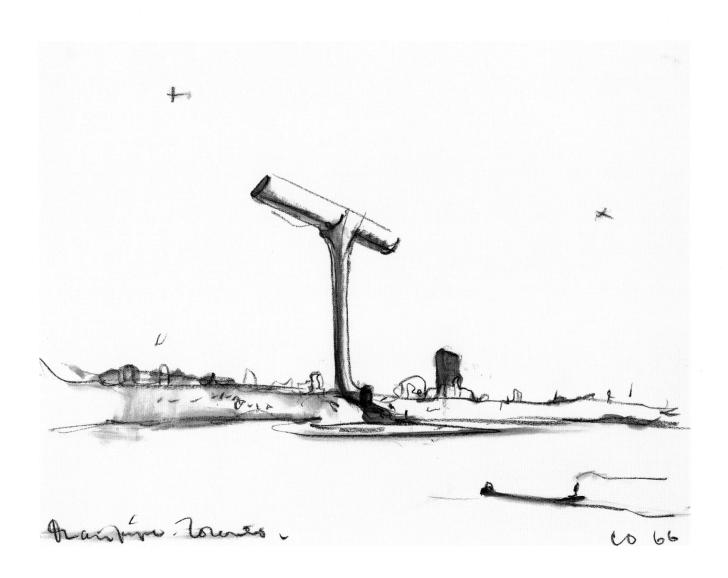

Manifolo Toronto. CO 66

42. *Base of a Colossal Drainpipe Monument, Toronto, with Waterfall*, 1967

113

43. *Soft Drainpipe (drawn for catalogue of* Dine—Oldenburg—Segal *group show at the Art Gallery of Ontario)*, 1966

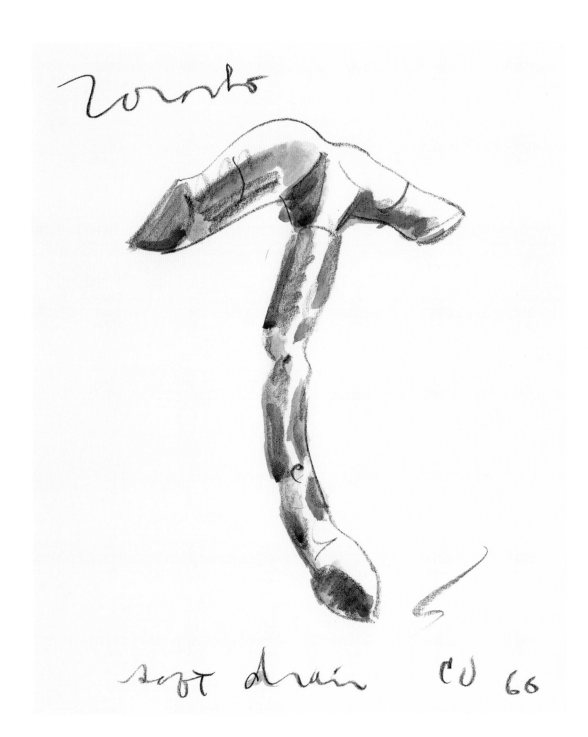

44. *Drainpipe—Dream State*, 1967

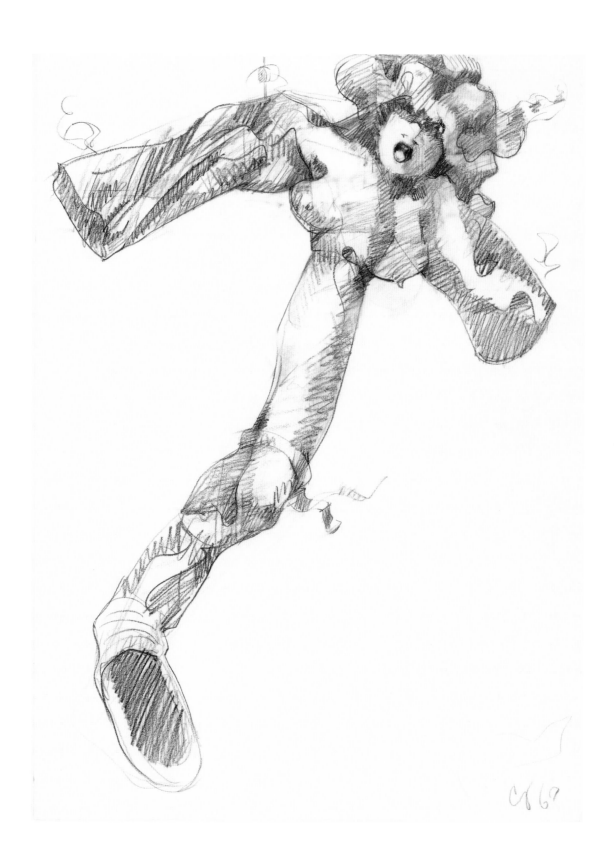

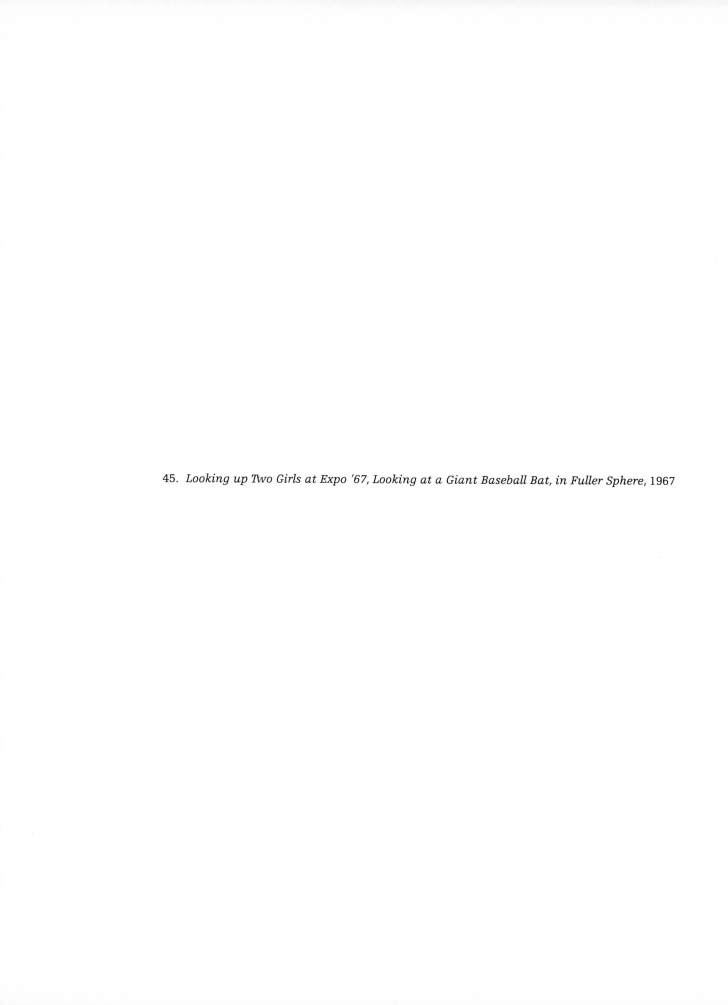

45. *Looking up Two Girls at Expo '67, Looking at a Giant Baseball Bat, in Fuller Sphere,* 1967

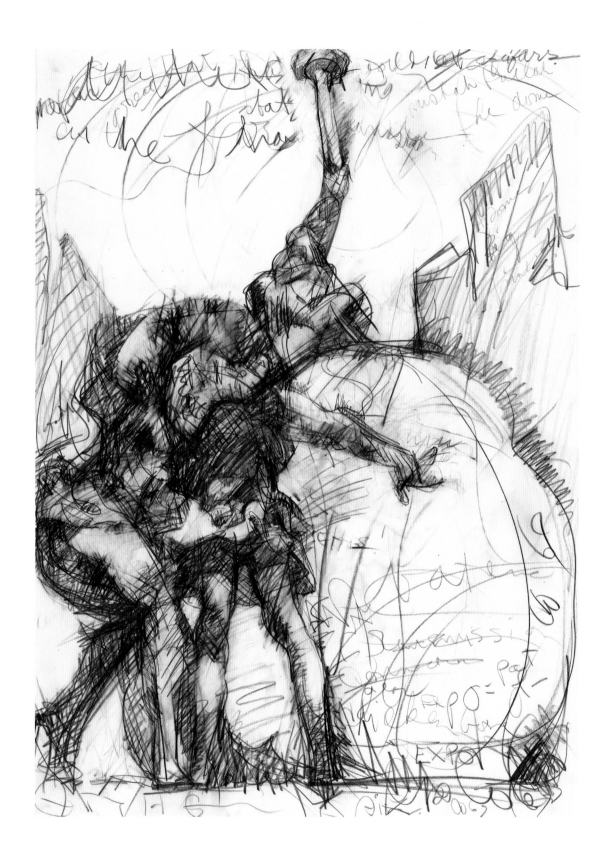

46. *Nude with Electric Plug,* 1967

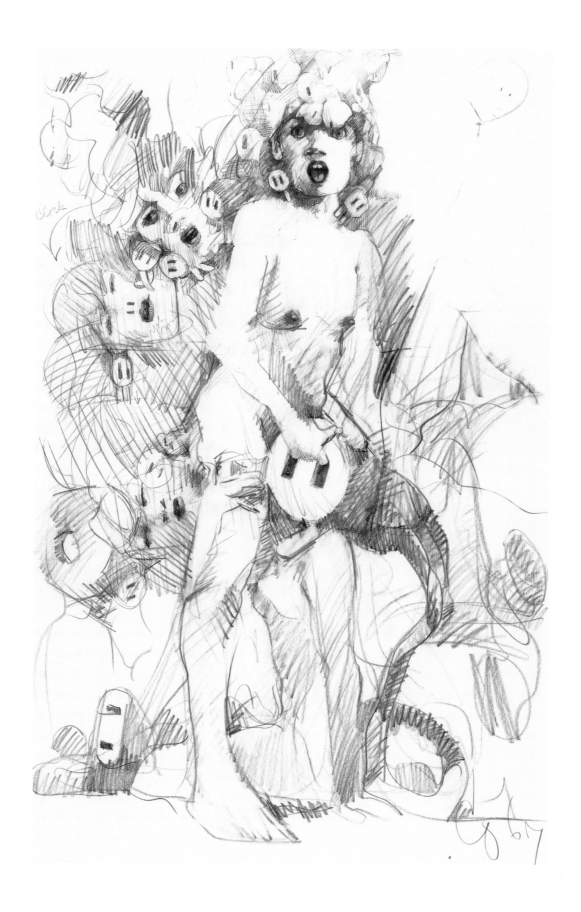

47. *Various Positions of a Giant Lipstick to Replace the Fountain of Eros, Piccadilly Circus, London*, 1966

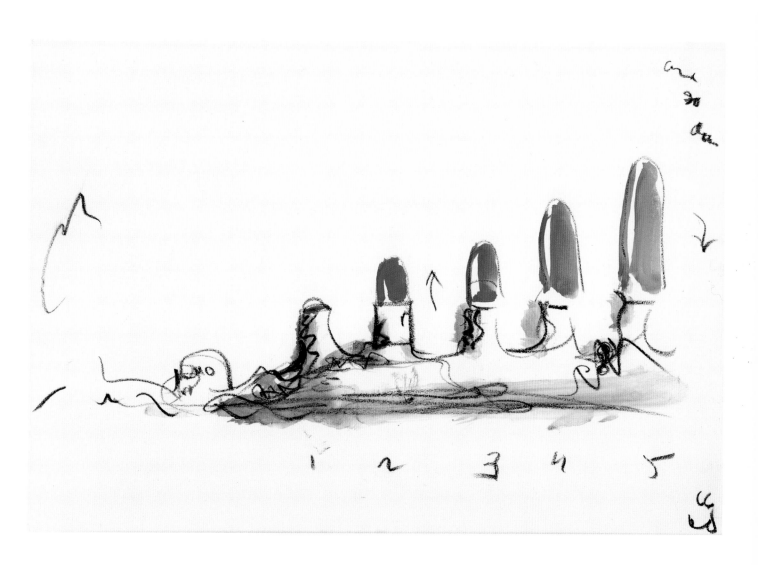

48. *Study for a Soft Sculpture in the Form of a Giant Lipstick,* 1967

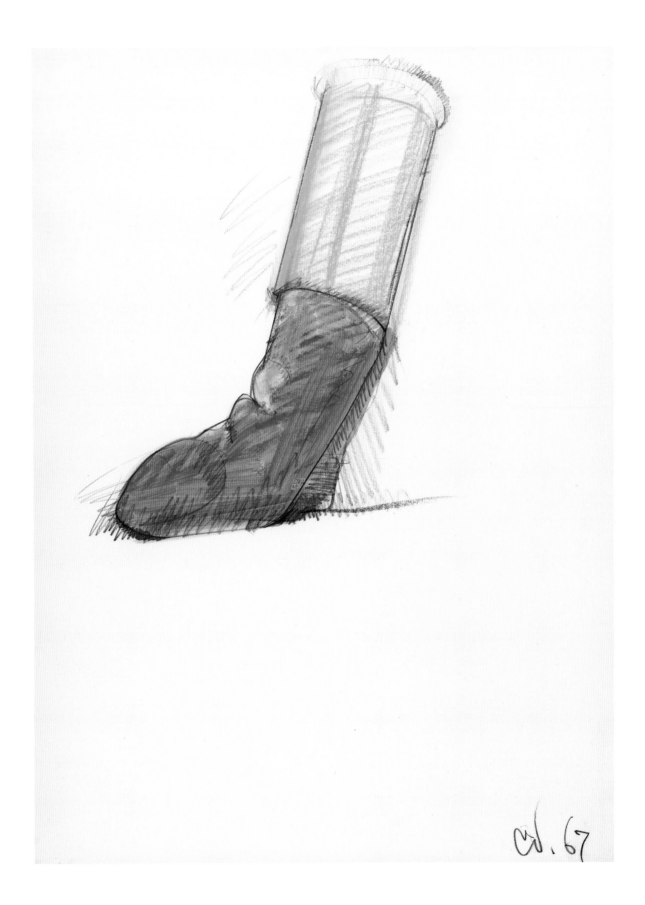

49. *Study for Feasible Monument: Lipstick, Yale*, 1969

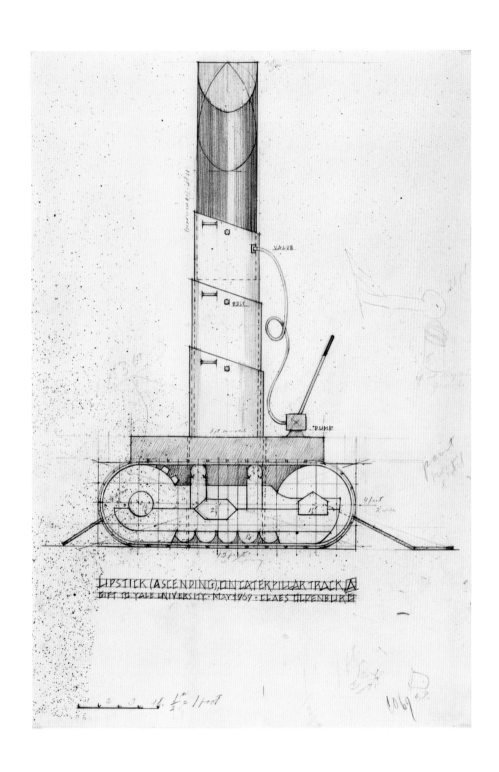

LIPSTICK (ASCENDING), ON CATERPILLAR TRACK [A]
GIFT TO YALE UNIVERSITY · MAY 1969 · CLAES OLDENBURG

50. *Small Monument for a London Street—Fallen Hat (for Adlai Stevenson)*, 1967

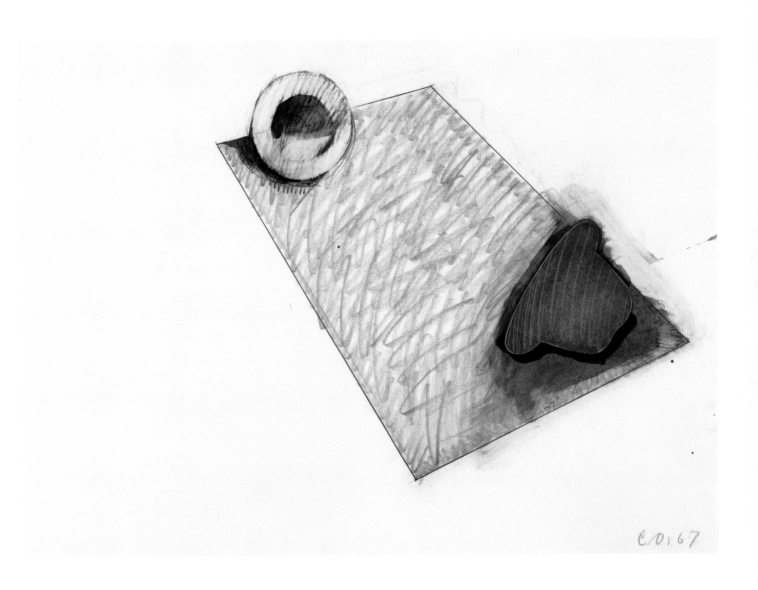

51. *Small Monument for a London Street—Fallen Hat (for Adlai Stevenson),* 1967

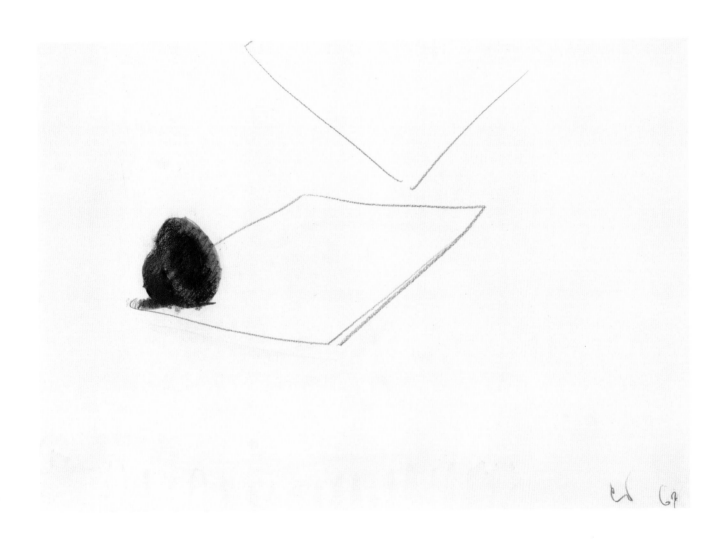

52. *Study for a Memorial to Clarence Darrow in the Lagoon of Jackson Park, Chicago: Rising Typewriter—Showing Stages*, 1967

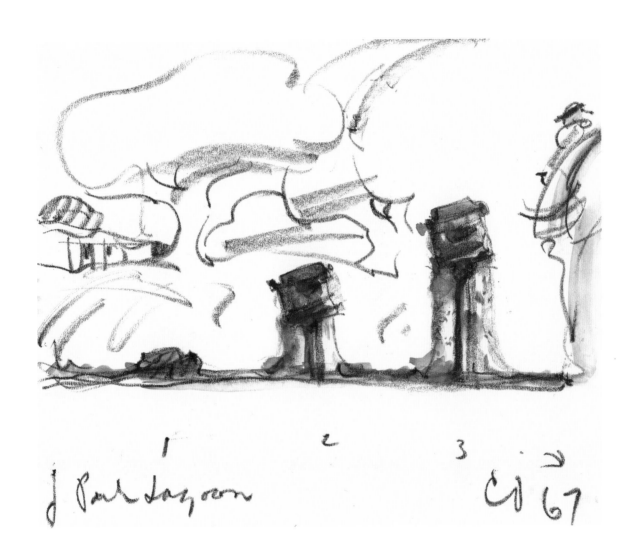

1 2 3

J Paul Lagoon CJ 67

53. *Notebook Page: Colossal Boots at the End of Navy Pier, Chicago*, 1967

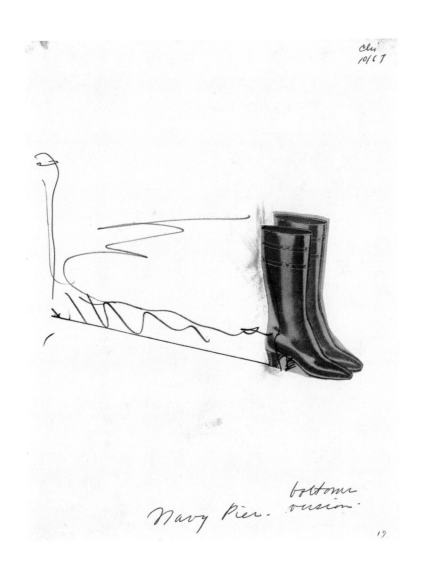

Navy Pier. bottom
version.

19

54. *Proposal for a Skyscraper in the Form of a Basketball Backstop with Ball in Net,* 1967

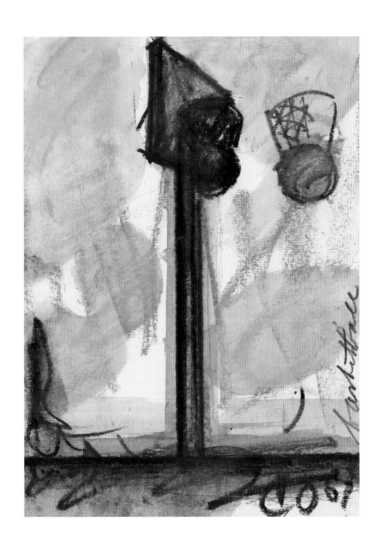

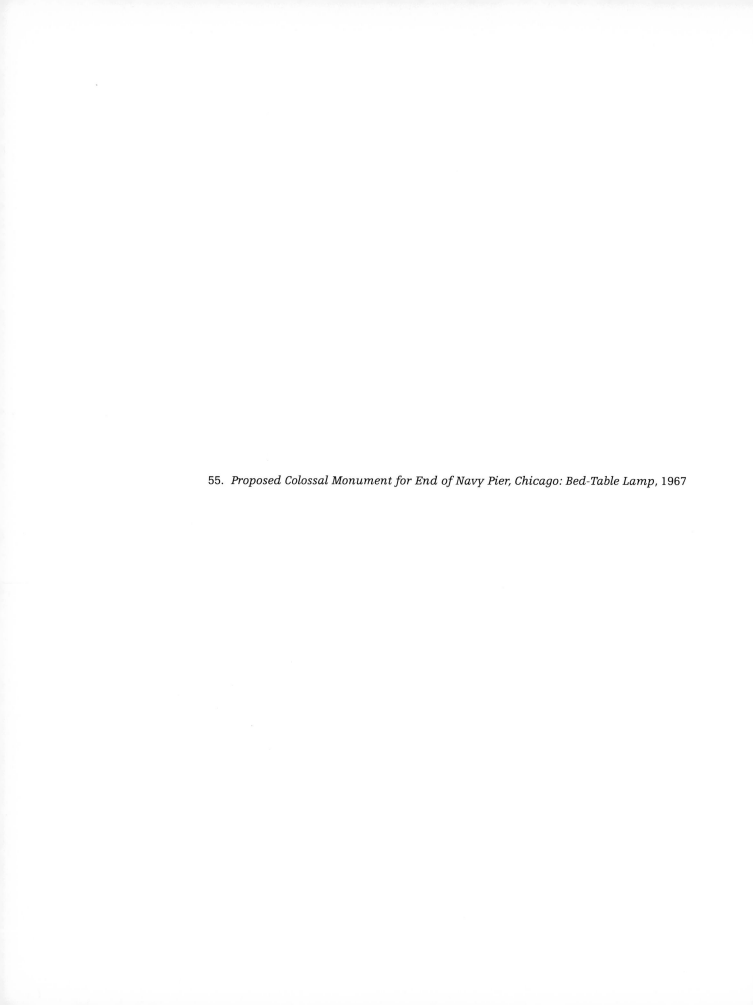

55. *Proposed Colossal Monument for End of Navy Pier, Chicago: Bed-Table Lamp*, 1967

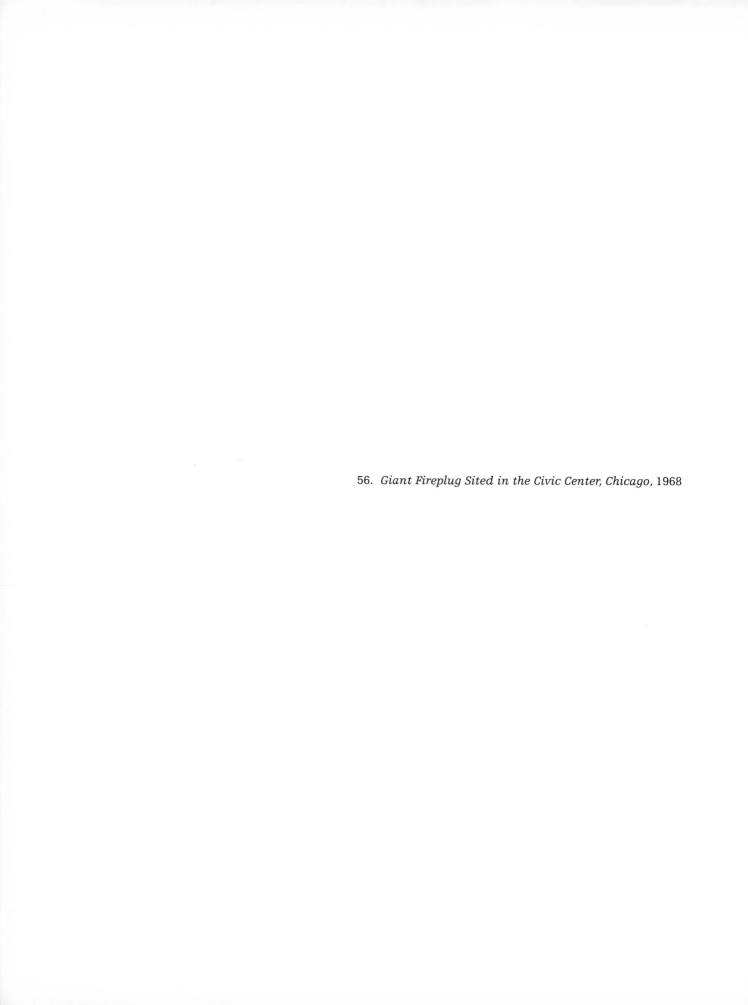

56. *Giant Fireplug Sited in the Civic Center, Chicago*, 1968

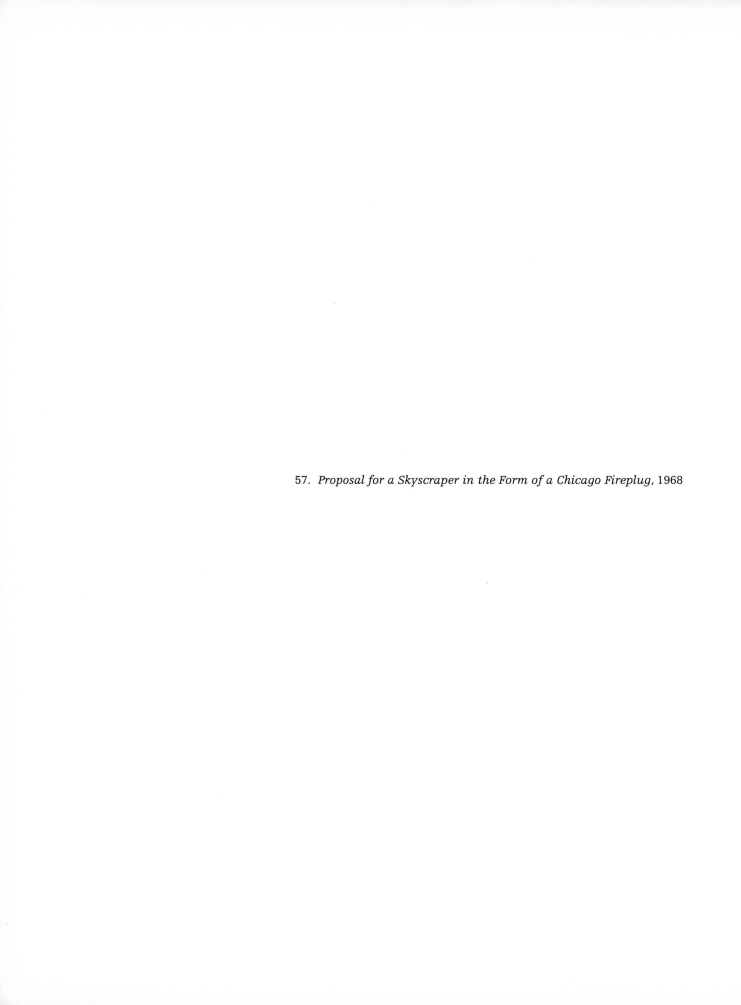

57. *Proposal for a Skyscraper in the Form of a Chicago Fireplug*, 1968

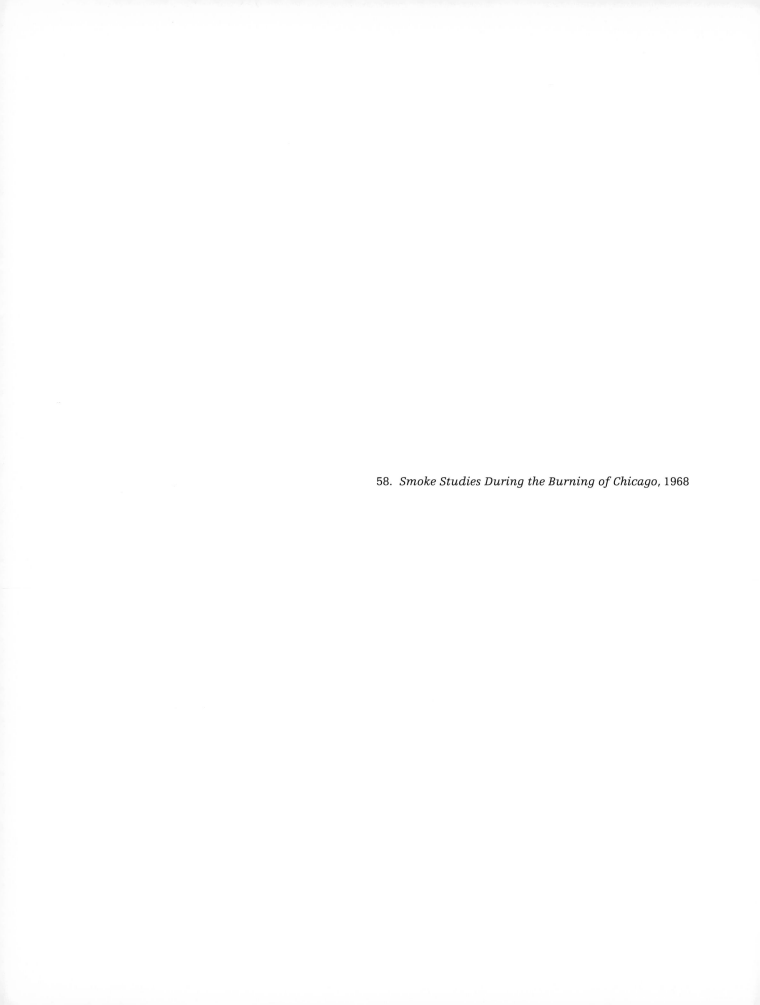

58. *Smoke Studies During the Burning of Chicago*, 1968

59. *The Letters "L" and "O" in Landscape,* 1968

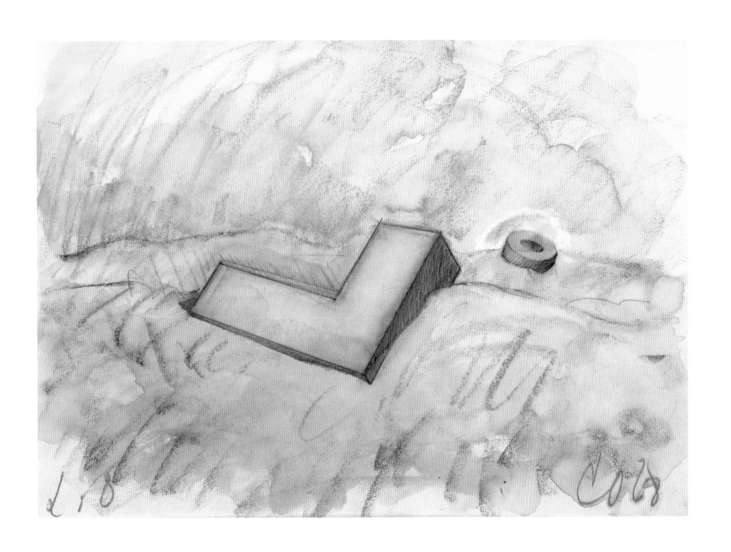

60. *Design for a Police Building Using the Word "POLICE"*, 1968

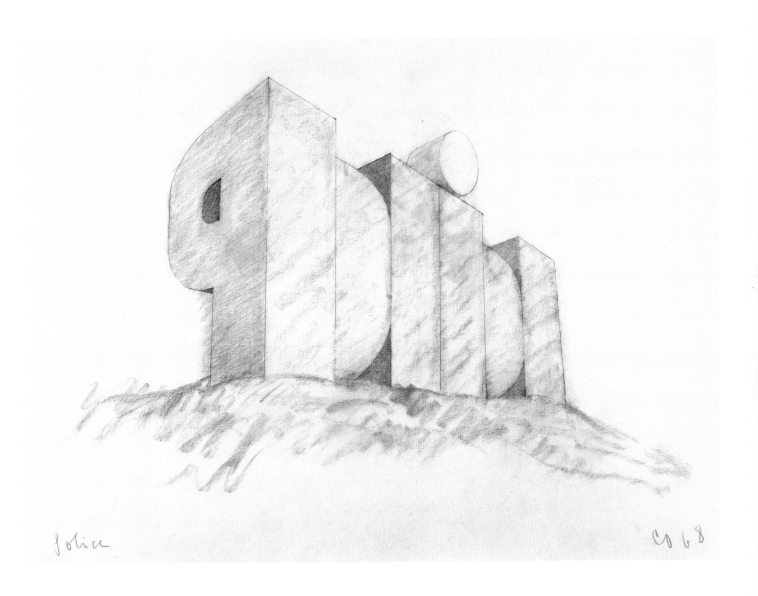

Police

CO 68

149

61. *Museum Design Based on a Cigarette Package*, 1968

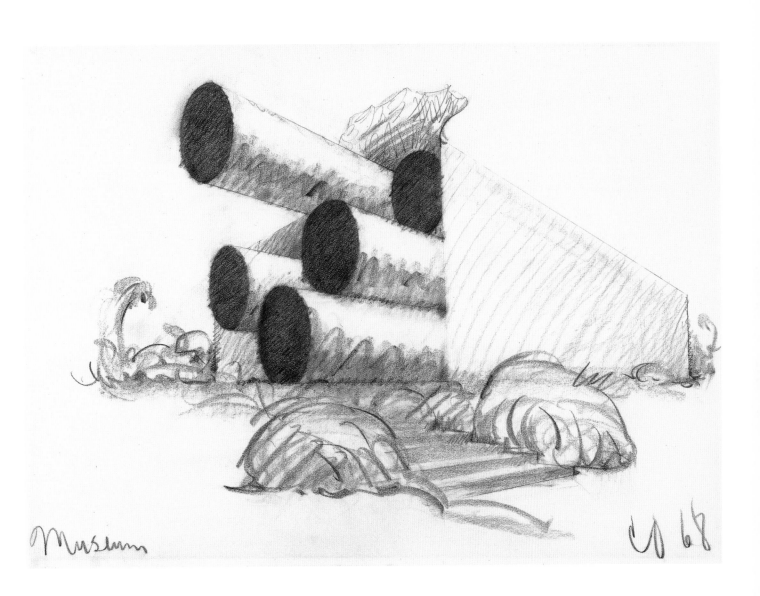

Museum CO 68

62. *Two Fagends Together, II,* 1968

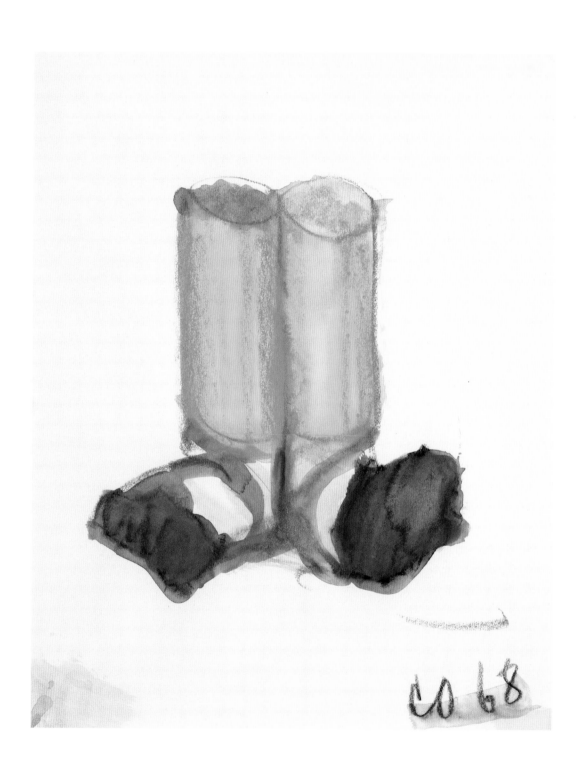

63. *Two Fagends Together, I*, 1968

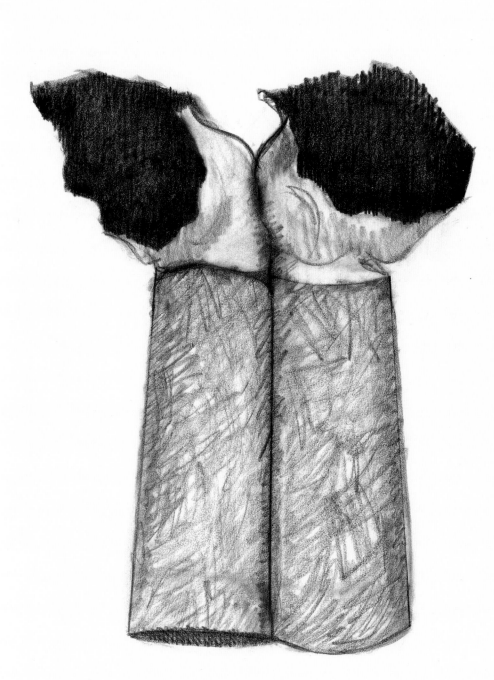

L. Lagunas

CU68

64. *Proposal for a Tomb in the Form of a Giant Punching Bag—with Obelisk*, 1968

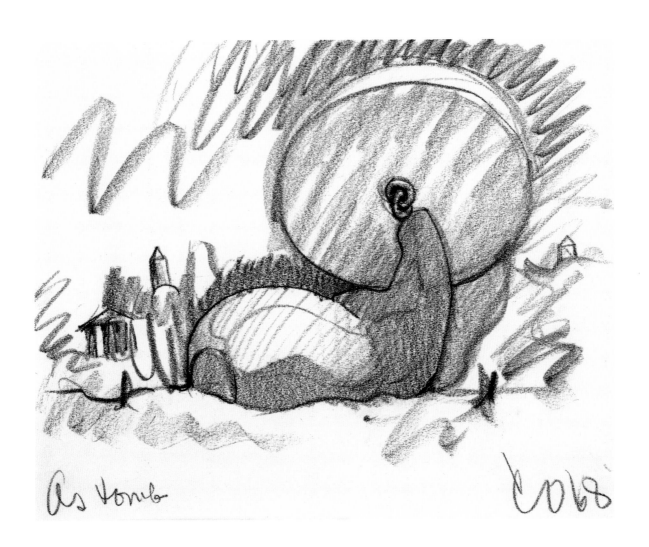

As Home

65. *Study of a Soft Fireplug, Inverted*, 1969

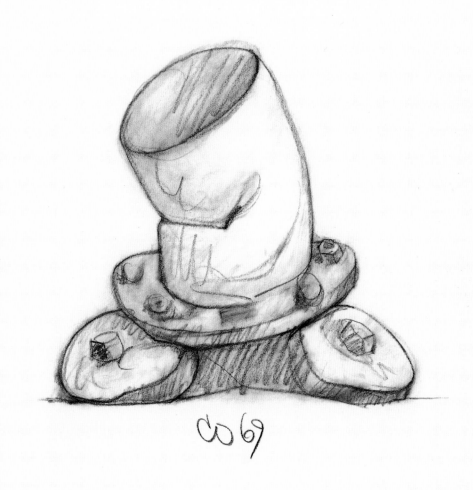

66. *Study of a Chicago Fireplug, Upside Down*, 1968

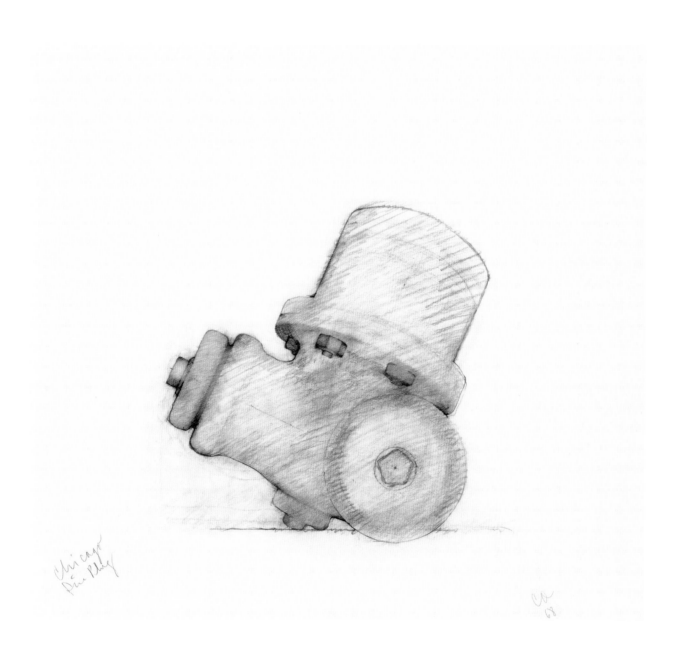

Chicago
Fire Plug

CO
68

67. *Proposed Colossal Monument for the End of Navy Pier,*
Chicago: Fireplug—Two Views, 1968

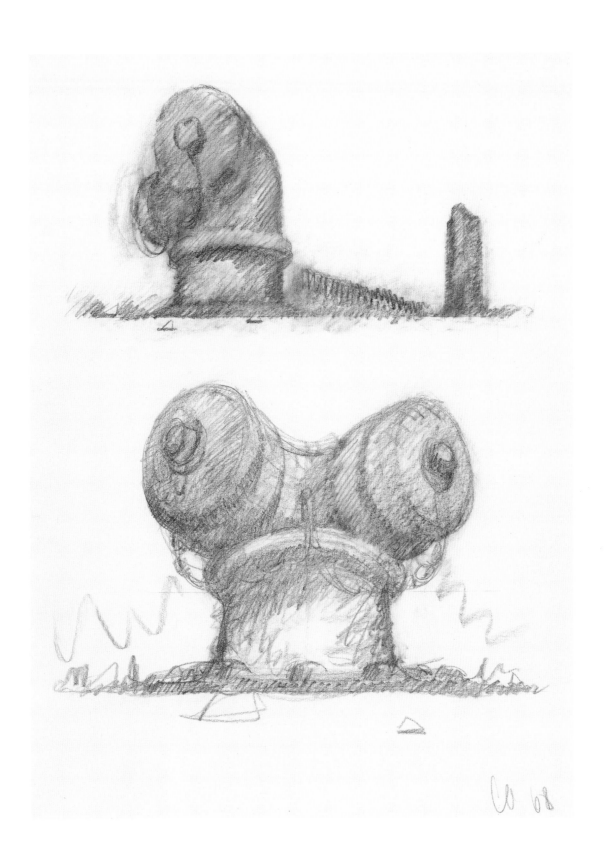

68. *Soft Fireplug*, 1969

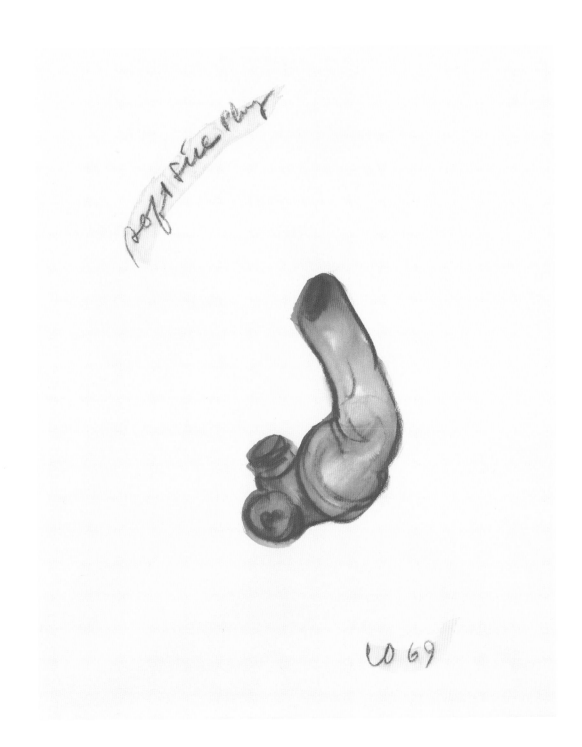

LO 69

69. *Study of a Nose*, 1968

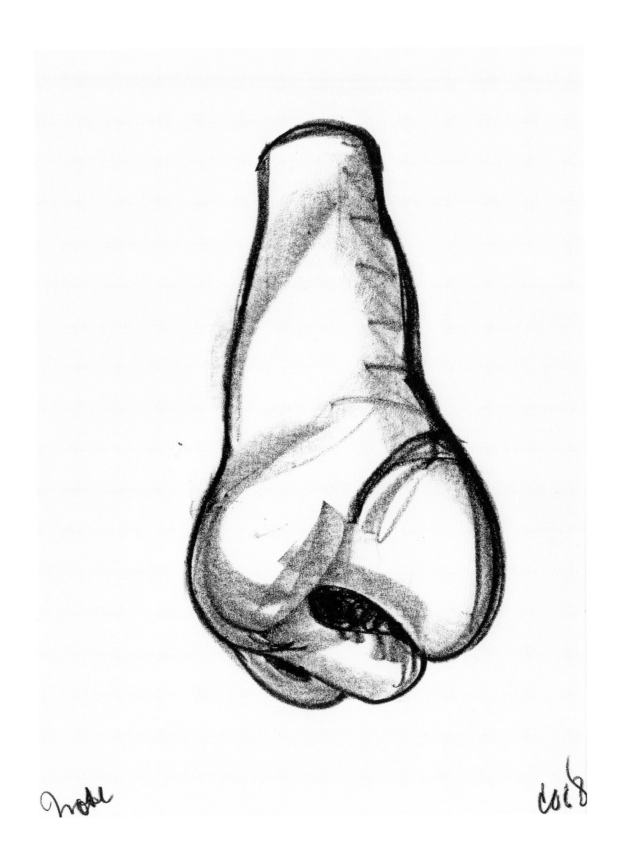

model

cole

70. *Giant Ice Bag Cross-Section, View II, New Haven*, 1969

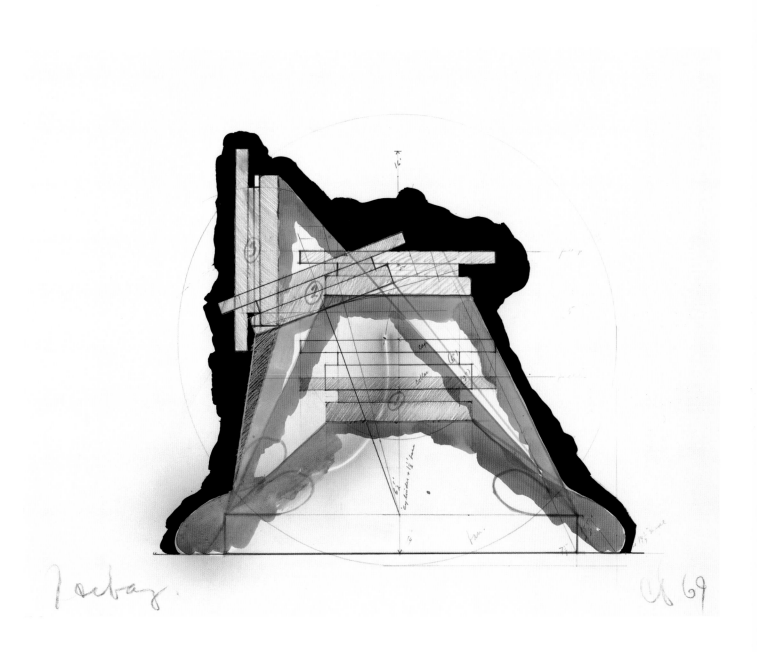

71. *Typewriter Erasers—Position Studies*, 1970

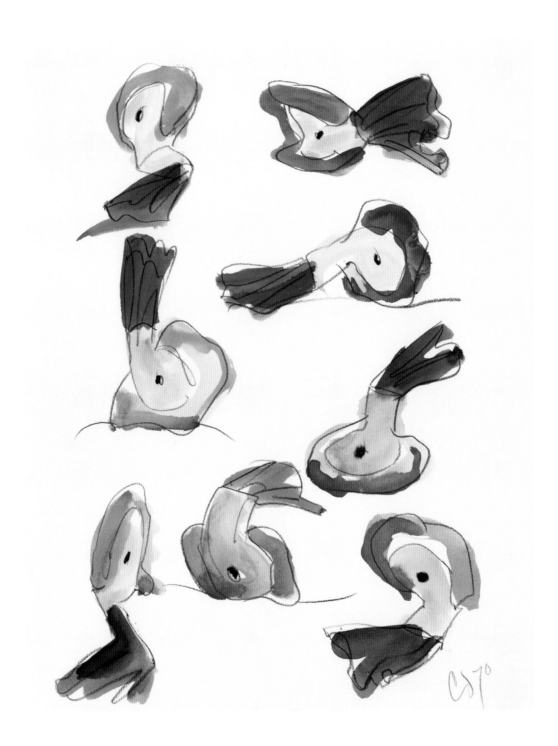

72. *Typewriter Eraser*, 1977

To Romiko + John,
in gratitude for a marvelous
visit, August 1977.

'77

73. *Perfume Bottle, Fallen*, 1992

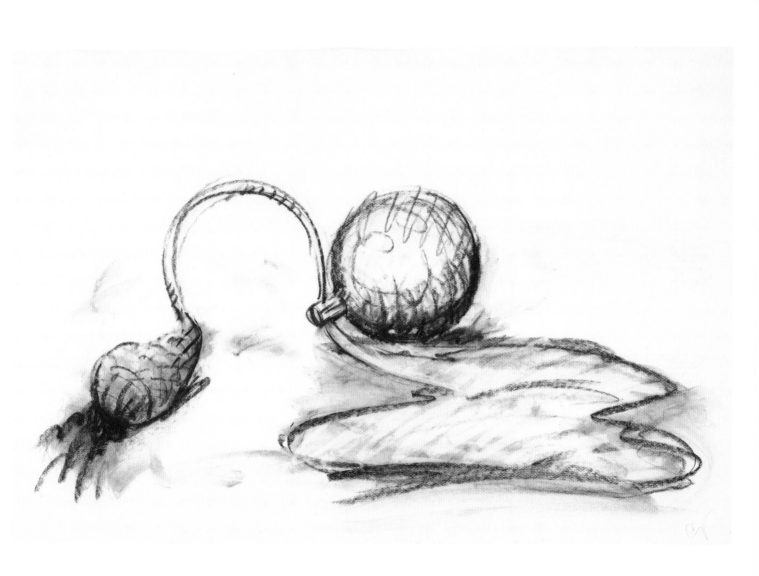

74. *Perfume Bottle, Fallen*, 1992

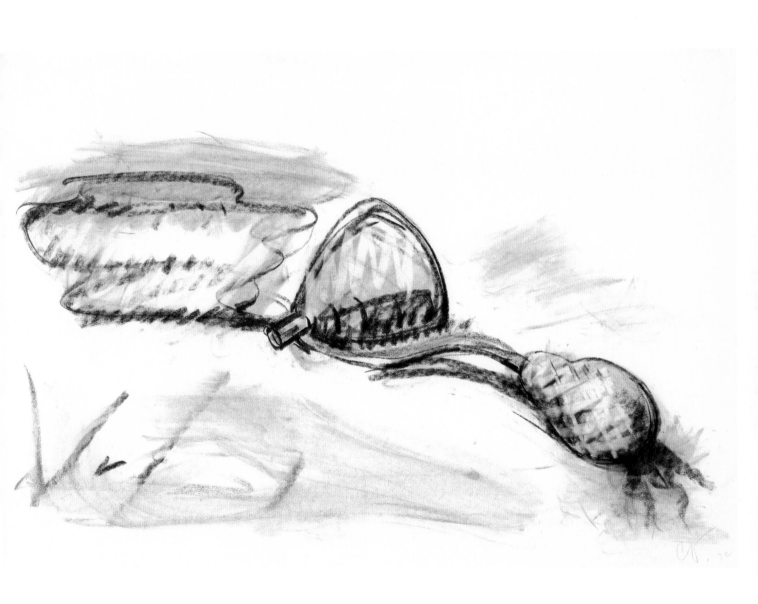

75. *Clarinet Bridge*, 1992

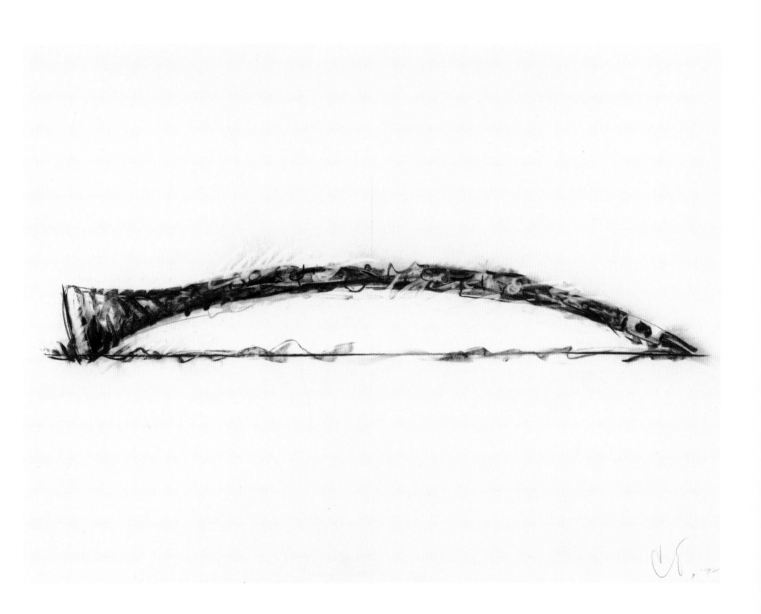

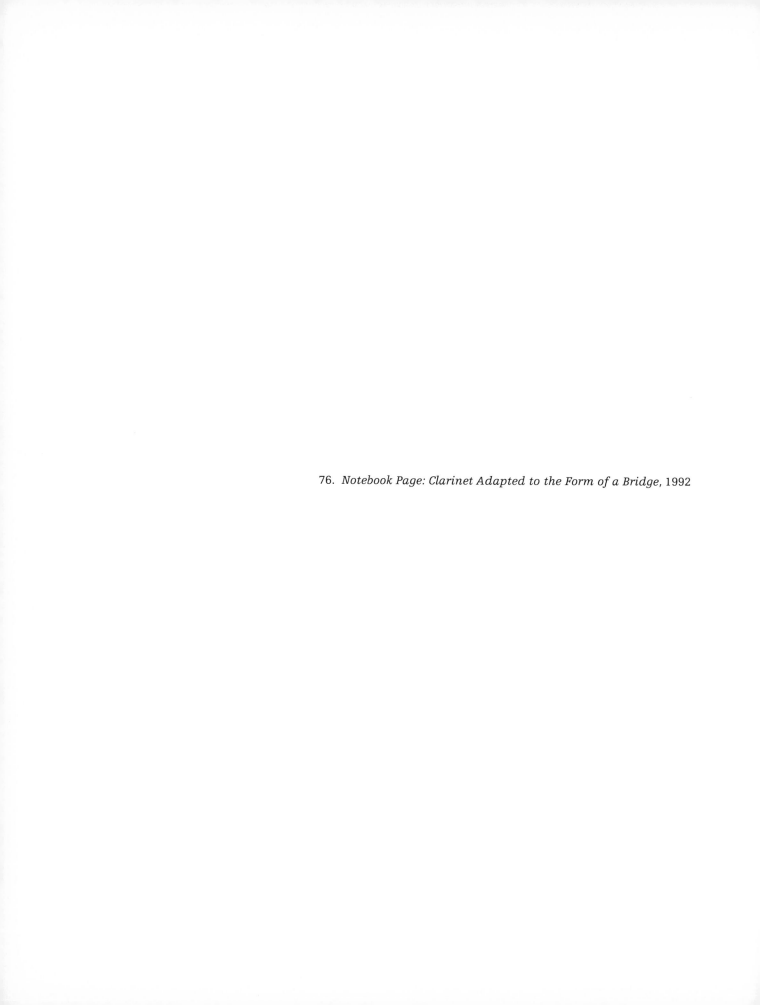

76. *Notebook Page: Clarinet Adapted to the Form of a Bridge,* 1992

77. *Notebook Page: Study for a House on the Shore of a Lake in the Form of a Blueberry Pie à la Mode*, 1992

78. *Blueberry Pie à la Mode, Sliding down a Hill,* 1996

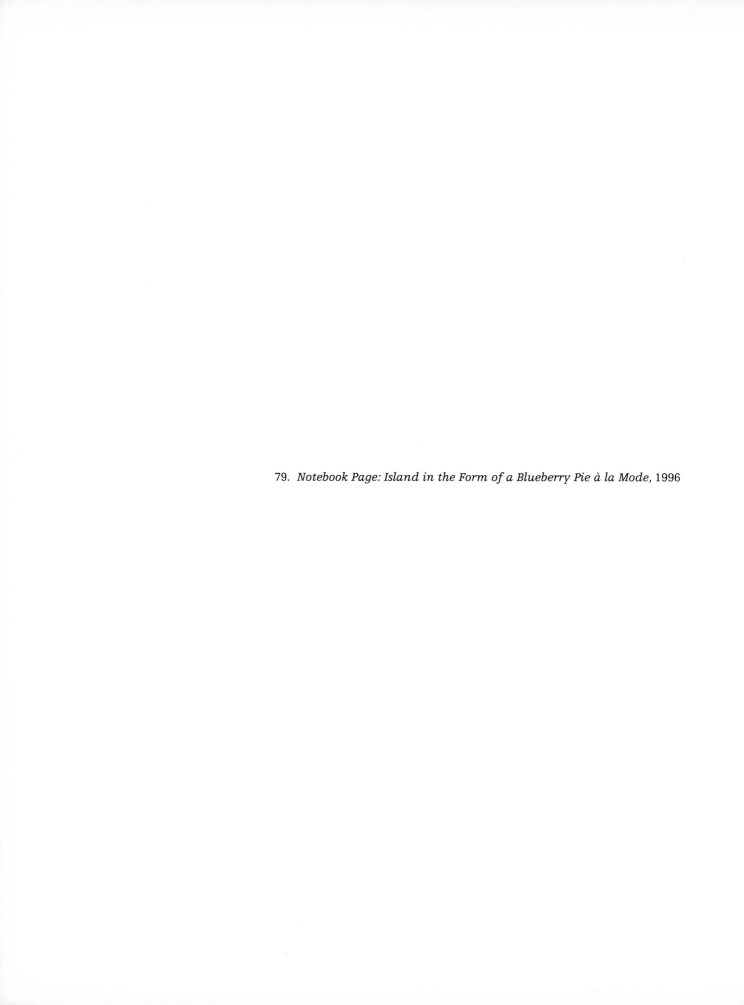

79. *Notebook Page: Island in the Form of a Blueberry Pie à la Mode*, 1996

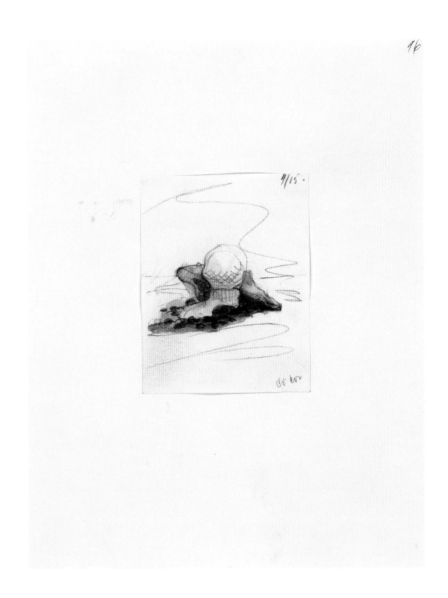

80. *Blueberry Pie Island,* 1998

81. *Notebook Page: Study for a Colossal Sculpture of a Woman's Legs, Walking, for Michigan Avenue, Chicago*, 1994

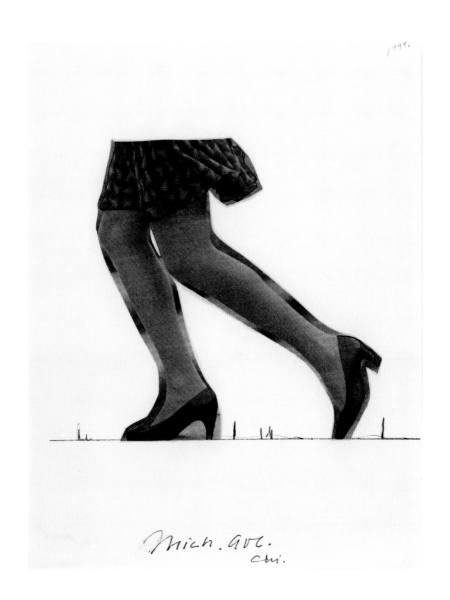

1994.

Mich. Ave.
Chi.

82. *Notebook Page: Study for a Colossal Sculpture of a Woman's Legs, Running,* 1994

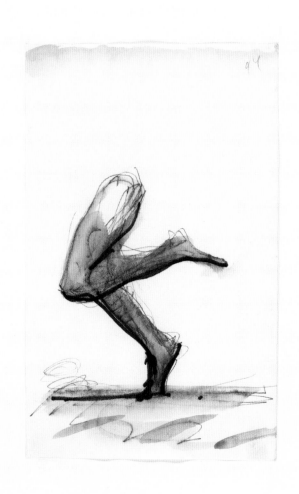

83. *Notebook Page: Variations on a Sculpture in the Form of a Saw,* 1994

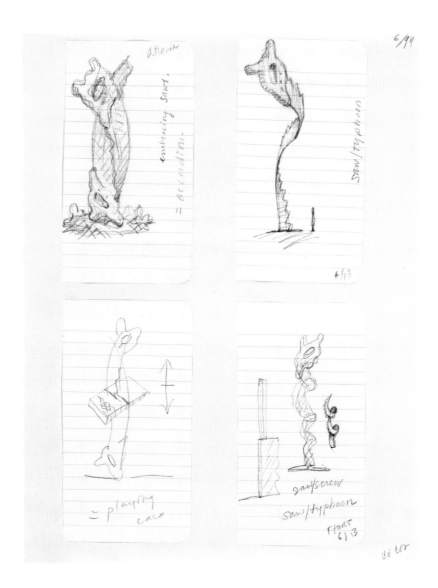

84. *Notebook Page: Saw-Tie*, 1994

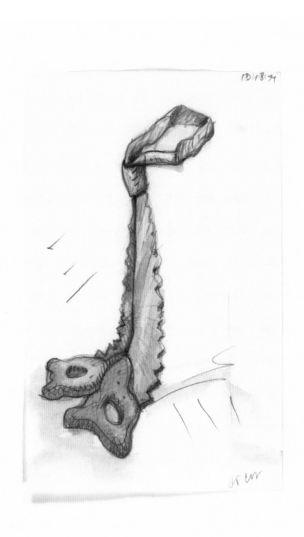

85. *Proposal for a Sculpture in the Form of a Saw, Sawing,* 1994

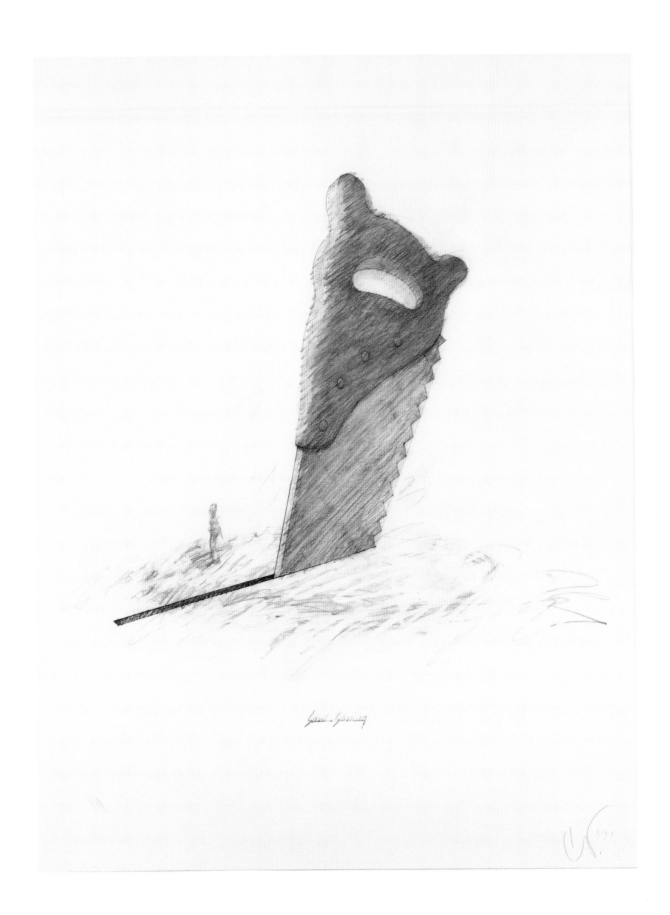

Saw - Gnawing

86. *Notebook Page: Shuttlecock Sculpture Studies,* 1993

87. *Notebook Page: Shuttlecock Sculpture Studies —"Am Earheart"*, 1993

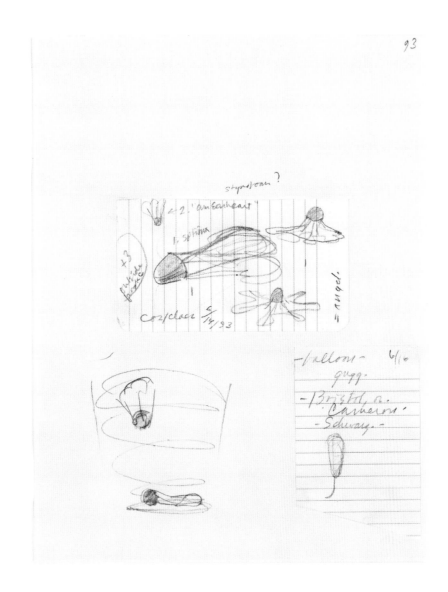

88. *Notebook Page: Soft Shuttlecock, One Feather Elevated*, 1994

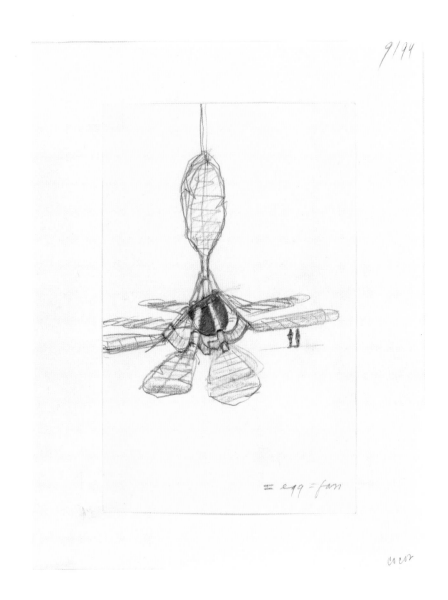

= egg = fan

9/94

89. *Notebook Page: Soft Shuttlecock, Spread on a Field*, 1994

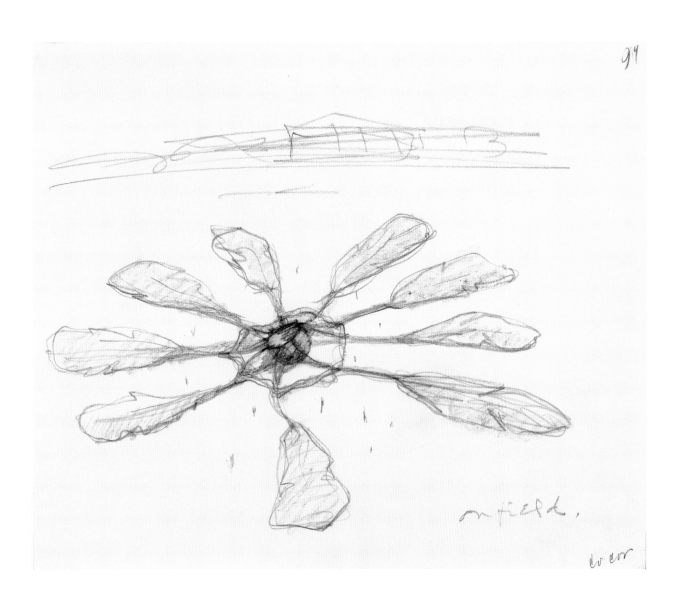

90. *Soft Shuttlecock, Raised*, 1994

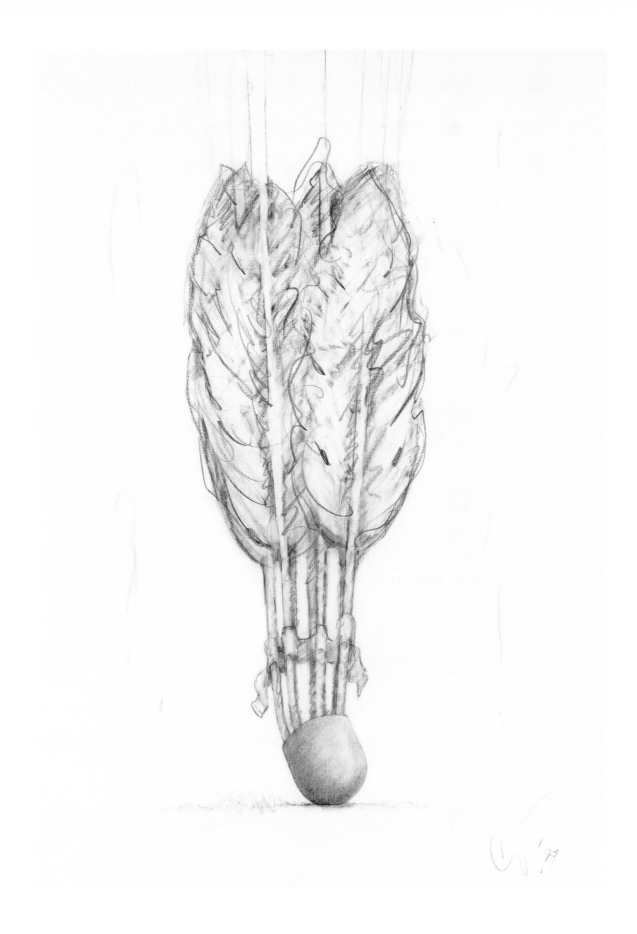

91. *Soft Shuttlecocks, Falling, Number Two*, 1995

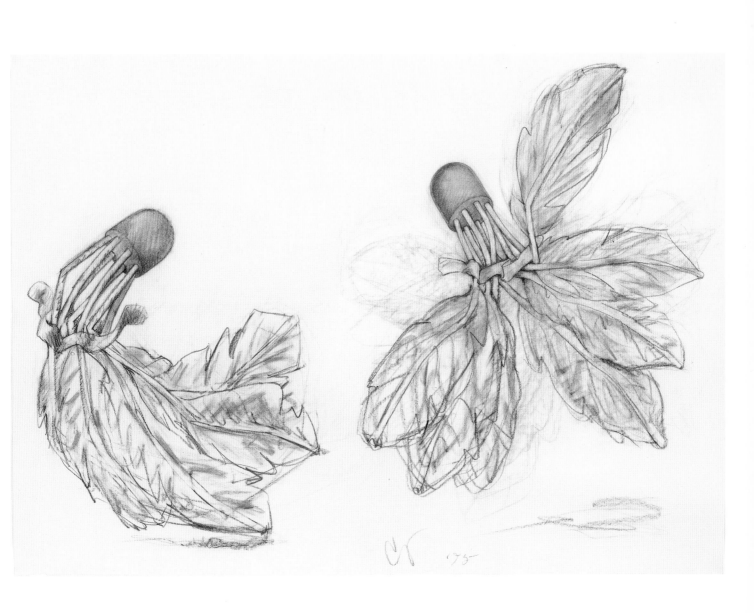

92. *Dream Pin*, 1998

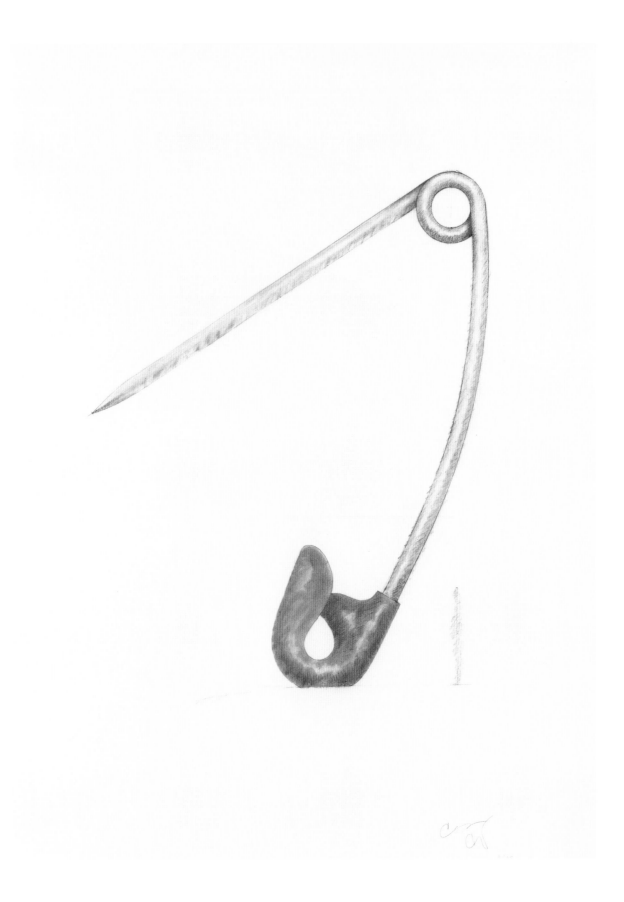

WORKS IN THE EXHIBITION

Drawings 1–72, 81, and 82 are by Claes Oldenburg; drawings 73–80 and 83–92 are by Claes Oldenburg with Coosje van Bruggen.

Unless otherwise indicated, all works are on paper. Dimensions are in inches, followed by centimeters; height precedes width. All works are in the Permanent Collection of the Whitney Museum of American Art, New York.

1. *Bicycle on Ground*, 1959
Crayon, 12 x 17 5/8 (30.5 x 44.8)
Gift of the Lauder Foundation, Evelyn and Leonard Lauder Fund 76.31

2. *Pat Reading in Bed, Lenox*, 1959
Crayon, 14 x 16 1/2 (35.6 x 41.9)
Gift of the American Contemporary Art Foundation, Leonard Lauder, Member 2002.4

3. *Man and Woman Walking on Street—Woman in Front*, 1960
Crayon, 13 15/16 x 11 11/16 (35.4 x 42.4)
Purchase, with funds from The Lauder Foundation, Evelyn and Leonard Lauder Fund for the Acquisition of Master Drawings and the Drawing Committee 99.116

4. *Street Scene—Man, Woman, TA*, 1960
Pencil, 13 7/8 x 16 5/8 (35.2 x 42.2)
Purchase, with funds from The Lauder Foundation, Evelyn and Leonard Lauder Fund for the Acquisition of Master Drawings and the Drawing Committee 99.115

5. *Study for the Poster*, New Media—New Forms, *Martha Jackson Gallery*, 1960
Pencil, crayon, ink, watercolor, collage, 13 1/2 x 9 15/16 (34.3 x 25.2)
Purchase, with funds from The Lauder Foundation, Evelyn and Leonard Lauder Fund 99.52.1

6. *Suggested Design for a Brochure Announcing* Ray Gun *Show at the Judson Gallery*, 1960
Crayon, pencil, pastel, typescript, 8 9/16 x 10 13/16 (21.8 x 27.5)
Purchase, with funds from The Lauder Foundation, Evelyn and Leonard Lauder Fund for the Acquisition of Master Drawings and the Drawing Committee 99.114a–b

7. *Nude Figure with American Flag—"ABC HOORAY"*, 1960
Ink and watercolor, 11 x 8 1/2 (27.9 x 21.6)
Gift of the American Contemporary Art Foundation, Leonard Lauder, Member 2002.3

8. *Sex Act*, 1961
Crayon and watercolor, 8 1/2 x 10 3/4 (21.6 x 27.3)
Gift of the American Contemporary Art Foundation, Leonard Lauder, Member 2002.5

9. *Silver Torso with Brown Underwear*, 1961
Enamel on newspaper, 22 1/8 x 15 3/8 (56.2 x 39.1)
Gift of the American Contemporary Art Foundation, Leonard Lauder, Member 2002.6

10. *Store Window—Yellow Shirt, Red Bow Tie*, 1961
Crayon and watercolor, 11 13/16 x 17 1/2 (30 x 44.5)
Gift of the American Contemporary Art Foundation, Leonard Lauder, Member 2002.7

11. *Store Window—Man's Shirt, Mannekin Torso, 39—on Fragment*, 1961
Crayon and watercolor, 18 x 21 (45.7 x 53.3), with irregular edges
Gift of the American Contemporary Art Foundation, Leonard Lauder, Member 2002.8

12. *Sketch for a Soft Sculpture in the Form of a Cake Wedge—Woman for Scale*, 1962
Crayon and watercolor, 11 x 13 11/16 (27.9 x 34.8)
Gift of the American Contemporary Art Foundation, Leonard Lauder, Member 2002.9

13. *Newspaper Stocking Against Newspaper Ads—"CHROMEQUEEN"*, 1962
Ink, watercolor, collage on newspaper, 15 x 10 3/4 (38.1 x 27.3)
Gift of the American Contemporary Art Foundation, Leonard Lauder, Member 2002.10

14. *Study for Announcement for One-Man Show at Dwan Gallery—Mickey Mouse with Red Heart*, 1963
Crayon and watercolor, 17 x 14 (43.2 x 35.6)
Gift of the American Contemporary Art Foundation,
Leonard Lauder, Member 2002.11

15. *Biplane*, 1963
Ink, 8 1/2 x 10 7/8 (21.6 x 27.6)
Gift of the American Contemporary Art Foundation,
Leonard Lauder, Member 2002.12

16. *Material and Scissors*, 1963
Ink and watercolor, 10 15/16 x 8 1/2 (27.8 x 21.6)
Purchase, with funds from The Lauder Foundation,
Evelyn and Leonard Lauder Fund for the Acquisition of
Master Drawings and the Drawing Committee 99.117

17. *Study for the Poster for* "4 Environments," *Sidney Janis Gallery—"THE HOME"*, 1963
Crayon and watercolor, 23 1/2 x 17 1/2 (59.7 x 44.5)
Gift of the American Contemporary Art Foundation,
Leonard Lauder, Member 2002.14

18. *Study for Zebra Chair—Bedroom Ensemble*, 1963
Chalk, colored pencil, spray enamel, watercolor, tape,
26 x 40 (66 x 101.6)
Gift of the American Contemporary Art Foundation,
Leonard Lauder, Member 2002.27

19. *Dressing Table*, 1963
Crayon and watercolor, 13 3/4 x 11 (34.9 x 27.9)
Gift of the American Contemporary Art Foundation,
Leonard Lauder, Member 2002.13

20. *Plan for a Sculpture in the Form of Wall Switches*, 1964
Pencil, ballpoint pen, crayon, collage, 29 x 23 5/8
(73.7 x 60)
Purchase, with funds from the Neysa Mein Purchase
Award 65.45

21. *Study for a Sculpture in the Form of a Vacuum Cleaner*, 1964
Pencil, crayon, ballpoint pen, watercolor, 23 11/16 x
18 3/16 (60.2 x 46.2)
Gift of the American Contemporary Art Foundation,
Leonard Lauder, Member 2002.17

22. *A Toilet*, 1964
Pencil, colored pencil, watercolor, 17 3/4 x 23 3/8
(45.1 x 59.4)
Gift of the American Contemporary Art Foundation,
Leonard Lauder, Member 2002.15

23. *Sketch for a Soft Toilet*, 1965
Crayon, pencil, watercolor, 11 11/16 x 9 (29.7 x 22.9)
Gift of the American Contemporary Art Foundation,
Leonard Lauder, Member 2002.29

24. *Baked Potato, Thrown in Corner, under Light Bulb*, 1965
Crayon and watercolor, 18 x 12 (45.7 x 30.5)
Gift of the American Contemporary Art Foundation,
Leonard Lauder, Member 2002.18

25. *Ketchup, Thick and Thin—from a N.Y.C. Billboard*, 1965
Crayon and watercolor, 17 1/2 x 12 (44.5 x 30.4)
Gift of the American Contemporary Art Foundation,
Leonard Lauder, Member 2002.21

26. *Icebox*, 1963
Crayon, pencil, watercolor, 13 3/4 x 11 1/16 (34.9 x 28.1)
Gift of the American Contemporary Art Foundation,
Leonard Lauder, Member 2002.19

27. *Study of a Silex Juicit*, 1965
Pencil, colored pencil, crayon, watercolor, 30 1/16 x
22 1/8 (76.4 x 56.2)
Gift of the American Contemporary Art Foundation,
Leonard Lauder, Member 2002.28

28. *Study of Fan Blades*, 1965
Pencil, crayon, spray enamel, 41 3/4 x 39 1/2 (106 x 100.3)
Gift of the American Contemporary Art Foundation,
Leonard Lauder, Member 2002.26

29. *Sketch of the Airflow, from a Snapshot (Front End)*, 1965
Crayon, pencil, watercolor, 30 x 22 (76.2 x 55.9)
Gift of the American Contemporary Art Foundation,
Leonard Lauder, Member 2002.25

30. *The Airflow—Top and Bottom, Front, Back, and Sides, To Be Folded into a Box (Study for Cover of* Art News*)*, 1965 [mounted and re-signed 1972]
Ballpoint pen, watercolor, collage, 17 1/4 x 17 7/8 (43.8 x 45.4)
Gift of the American Contemporary Art Foundation, Leonard Lauder, Member 2002.30

31. *Study for a Soft Sculpture in the Form of an Airflow Instrument Panel, Wheel, Gearshift, Etc.*, 1965 [signed 1967]
Crayon and watercolor, 29 7/8 x 22 (75.9 x 55.9)
Gift of the American Contemporary Art Foundation, Leonard Lauder, Member 2002.45

32. *Proposed Colossal Monument for Lower East Side—Ironing Board*, 1965
Crayon and watercolor, 11 15/16 x 17 11/16 (30.3 x 44.9)
Gift of the American Contemporary Art Foundation, Leonard Lauder, Member 2002.20

33. *Proposed Colossal Monument for Park Avenue, N.Y.C.—Good Humor Bar*, 1965
Pen, ink, watercolor, 12 1/8 x 17 3/4 (30.8 x 45.1)
Gift of the American Contemporary Art Foundation, Leonard Lauder, Member 2002.23

34. *Proposed Colossal Monument for Ellis Island—Shrimp*, 1965
Crayon and watercolor, 11 15/16 x 15 15/16 (30.3 x 40.5)
Gift of the American Contemporary Art Foundation, Leonard Lauder, Member 2002.24

35. *Proposed Colossal Monument for Central Park North, N.Y.C.—Teddy Bear*, 1965
Crayon and watercolor, 23 7/8 x 18 7/8 (60.6 x 47.9)
Gift of the American Contemporary Art Foundation, Leonard Lauder, Member 2002.22

36. *Proposal for a Cathedral in the Form of a Colossal Faucet, Lake Union, Seattle*, 1972
Pencil, colored pencil, crayon, watercolor, 29 x 22 7/8 (73.7 x 58.1)
Purchase, with funds from Knoll International, Inc. 80.35

37. *Proposal for Monument in a London Park in the Form of an Electric Shaver, with Cord*, 1966
Crayon and watercolor, 22 1/16 x 14 15/16 (56 x 37.9)
Gift of the American Contemporary Art Foundation, Leonard Lauder, Member 2002.33

38. *"Capric"—Adapted to a Monument for a Park*, 1966
Crayon and watercolor, 22 1/4 x 30 (56.5 x 76.2)
Gift of the American Contemporary Art Foundation, Leonard Lauder, Member 2002.32

39. *Banana*, 1966
Crayon and watercolor, 7 13/16 x 5 (19.8 x 12.7)
Gift of the American Contemporary Art Foundation, Leonard Lauder, Member 2002.31

40. *Proposed Colossal Underground Monument—Drainpipe*, 1967
Crayon, pencil, colored pencil, watercolor, spray enamel, collage, 30 1/4 x 21 15/16 (76.8 x 55.7)
Gift of the American Contemporary Art Foundation, Leonard Lauder, Member 2002.42

41. *Proposed Colossal Monument for Toronto—Drainpipe, View from Lake*, 1966
Crayon and watercolor, 17 13/16 x 23 5/8 (45.2 x 60)
Gift of the American Contemporary Art Foundation, Leonard Lauder, Member 2002.35

42. *Base of a Colossal Drainpipe Monument, Toronto, with Waterfall*, 1967
Pencil and watercolor, 24 x 22 (61 x 55.9)
Gift of the American Contemporary Art Foundation, Leonard Lauder, Member 2002.16

43. *Soft Drainpipe (drawn for catalogue of* Dine—Oldenburg—Segal *group show at the Art Gallery of Ontario)*, 1966
Crayon and watercolor, 18 1/8 x 14 15/16 (46 x 37.9)
Gift of the American Contemporary Art Foundation, Leonard Lauder, Member 2002.34

44. *Drainpipe—Dream State*, 1967
Pencil and crayon, 29 15/16 x 22 1/4 (76 x 56.5)
Purchase, with funds from The Lauder Foundation, Evelyn and Leonard Lauder Fund for the Acquisition of Master Drawings and the Drawing Committee 2000.6

45. *Looking up Two Girls at Expo '67, Looking at a Giant Baseball Bat, in Fuller Sphere*, 1967
Pencil and colored pencil, 30 x 22 1/16 (76.2 x 56)
Gift of the American Contemporary Art Foundation, Leonard Lauder, Member 2002.46

46. *Nude with Electric Plug*, 1967
Pencil, colored pencil, watercolor, 39 7/8 x 26 1/16
(101.3 x 66.2)
Gift of the American Contemporary Art Foundation,
Leonard Lauder, Member 2002.39

47. *Various Positions of a Giant Lipstick to Replace the
Fountain of Eros, Piccadilly Circus, London*, 1966
Crayon and watercolor, 18 x 24 (45.7 x 61)
Gift of the American Contemporary Art Foundation,
Leonard Lauder, Member 2002.36

48. *Study for a Soft Sculpture in the Form of a Giant
Lipstick*, 1967
Crayon, pencil, watercolor, 29 7/8 x 22 1/4 (75.9 x 56.5)
Purchase, with funds from The Lauder Foundation,
Evelyn and Leonard Lauder Fund for the Acquisition of
Master Drawings and the Drawing Committee 2000.7

49. *Study for Feasible Monument: Lipstick, Yale*, 1969
Pencil, colored pencil, spray enamel, 16 5/8 x 11 1/8
(42.2 x 28.3)
Purchase, with funds from Evelyn and Leonard Lauder
95.87

50. *Small Monument for a London Street—Fallen Hat
(for Adlai Stevenson)*, 1967
Pencil, colored pencil, watercolor, 23 1/4 x 32
(59.1 x 81.3)
Gift of the American Contemporary Art Foundation,
Leonard Lauder, Member 2002.43

51. *Small Monument for a London Street—Fallen Hat
(for Adlai Stevenson)*, 1967
Pencil, crayon, watercolor, 15 1/2 x 22 (39.4 x 55.9)
Gift of the American Contemporary Art Foundation,
Leonard Lauder, Member 2002.44

52. *Study for a Memorial to Clarence Darrow in the
Lagoon of Jackson Park, Chicago: Rising Typewriter—
Showing Stages*, 1967
Crayon and watercolor, 13 15/16 x 16 3/4 (35.4 x 42.5)
Gift of the American Contemporary Art Foundation,
Leonard Lauder, Member 2002.37

53. *Notebook Page: Colossal Boots at the End of Navy
Pier, Chicago*, 1967
Ballpoint pen, felt pen, clipping, 10 3/4 x 8 1/4
(27.3 x 21)
Gift of the American Contemporary Art Foundation,
Leonard Lauder, Member 2002.38

54. *Proposal for a Skyscraper in the Form of a
Basketball Backstop with Ball in Net*, 1967
Crayon, pencil, watercolor, 9 3/4 x 9 (24.8 x 22.9)
Gift of the American Contemporary Art Foundation,
Leonard Lauder, Member 2002.40

55. *Proposed Colossal Monument for End of Navy Pier,
Chicago: Bed-Table Lamp*, 1967
Crayon and watercolor, 13 5/8 x 11 (34.6 x 27.9)
Gift of the American Contemporary Art Foundation,
Leonard Lauder, Member 2002.41

56. *Giant Fireplug Sited in the Civic Center, Chicago*,
1968
Crayon, ballpoint pen, watercolor, 10 15/16 x 8 7/16
(27.8 x 21.4)
Gift of the American Contemporary Art Foundation,
Leonard Lauder, Member 2002.48

57. *Proposal for a Skyscraper in the Form of a Chicago
Fireplug*, 1968
Crayon and watercolor, 13 1/2 x 10 3/4 (34.3 x 27.3)
Gift of the American Contemporary Art Foundation,
Leonard Lauder, Member 2002.50

58. *Smoke Studies During the Burning of Chicago*, 1968
Spray enamel, pencil, ballpoint pen, collage, 8 1/2 x 11
(21.6 x 27.9)
Gift of the American Contemporary Art Foundation,
Leonard Lauder, Member 2002.53

59. *The Letters "L" and "O" in Landscape*, 1968
Crayon, colored pencil, pencil, watercolor,
9 3/16 x 13 11/16 (23.3 x 34.8)
Gift of the American Contemporary Art Foundation,
Leonard Lauder, Member 2002.56

60. *Design for a Police Building Using the Word
"POLICE"*, 1968
Pencil, 22 x 30 (55 x 76.2)
Gift of the American Contemporary Art Foundation,
Leonard Lauder, Member 2002.47

61. *Museum Design Based on a Cigarette Package*, 1968
Pencil, 21 15/16 x 30 (55.7 x 76.2)
Gift of the American Contemporary Art Foundation,
Leonard Lauder, Member 2002.49

62. *Two Fagends Together, II*, 1968
Crayon and watercolor, 13 11/16 x 10 15/16 (34.8 x 27.8)
Gift of the American Contemporary Art Foundation,
Leonard Lauder, Member 2002.58

63. *Two Fagends Together, I*, 1968
Pencil, 30 x 22 (76.2 x 55.9)
Gift of the American Contemporary Art Foundation,
Leonard Lauder, Member 2002.57

64. *Proposal for a Tomb in the Form of a Giant
Punching Bag—with Obelisk*, 1968
Crayon, 11 x 13 3/4 (27.9 x 34.9)
Gift of the American Contemporary Art Foundation,
Leonard Lauder, Member 2002.51

65. *Study of a Soft Fireplug, Inverted*, 1969
Pencil, 26 3/4 x 22 (67.9 x 55.9)
Gift of the American Contemporary Art Foundation,
Leonard Lauder, Member 2002.61

66. *Study of a Chicago Fireplug, Upside Down*, 1968
Pencil and colored pencil, 19 3/4 x 21 3/4 (50.2 x 55.2)
Gift of the American Contemporary Art Foundation,
Leonard Lauder, Member 2002.54

67. *Proposed Colossal Monument for the End of Navy
Pier, Chicago: Fireplug—Two Views*, 1968
Pencil, 30 x 22 (76.2 x 55.9)
Gift of the American Contemporary Art Foundation,
Leonard Lauder, Member 2002.52

68. *Soft Fireplug*, 1969
Crayon and watercolor, 13 5/8 x 11 (34.6 x 27.9)
Gift of the American Contemporary Art Foundation,
Leonard Lauder, Member 2002.60

69. *Study of a Nose*, 1968
Crayon, 29 7/8 x 22 (75.9 x 55.9)
Gift of the American Contemporary Art Foundation,
Leonard Lauder, Member 2002.55

70. *Giant Ice Bag Cross-Section, View II, New Haven*,
1969
Pencil, ink, felt pen, colored pencil, spray enamel,
watercolor, 23 x 29 (58.4 x 73.7)
Gift of the American Contemporary Art Foundation,
Leonard Lauder, Member 2002.59

71. *Typewriter Erasers—Position Studies*, 1970
Colored pencil and watercolor, 14 3/8 x 11 3/8
(36.5 x 28.9)
Gift of the American Contemporary Art Foundation,
Leonard Lauder, Member 2002.62

72. *Typewriter Eraser*, 1977
Crayon and watercolor, 16 1/2 x 11 (41.9 x 27.9)
Gift of the American Contemporary Art Foundation,
Leonard Lauder, Member 2002.63

73. *Perfume Bottle, Fallen*, 1992
Charcoal, 25 3/4 x 39 3/8 (65.4 x 100)
Gift of LWG Family Partners, L.P. E.2001.364

74. *Perfume Bottle, Fallen*, 1992
Charcoal, 25 3/4 x 37 3/4 (65.4 x 95.9)
Gift of LWG Family Partners, L.P. E.2001.365

75. *Clarinet Bridge*, 1992
Charcoal, 37 3/4 x 50 (95.9 x 127)
Gift of the American Contemporary Art Foundation,
Leonard Lauder, Member 2002.64

76. *Notebook Page: Clarinet Adapted to the Form of a
Bridge*, 1992
Felt pen and clipping, 8 1/2 x 11 (21.6 x 27.9)
Gift of Claes Oldenburg and Coosje van Bruggen
2001.216

77. *Notebook Page: Study for a House on the Shore of a
Lake in the Form of a Blueberry Pie à la Mode*, 1992
Pencil and watercolor, 4 7/16 x 3 1/2 (11.3 x 8.9), on sheet
11 x 8 1/2 (27.9 x 21.6)
Gift of Claes Oldenburg and Coosje van Bruggen
2001.215

78. *Blueberry Pie à la Mode, Sliding down a Hill*, 1996
Charcoal and pastel, 39 1/2 x 30 1/8 (100.3 x 76.5)
Gift of the American Contemporary Art Foundation,
Leonard Lauder, Member 2002.65

79. *Notebook Page: Island in the Form of a Blueberry Pie
à la Mode*, 1996
Pencil and watercolor, 4 3/8 x 3 1/2 (11.1 x 8.9), on sheet
11 x 8 1/2 (27.9 x 21.6)
Gift of Claes Oldenburg and Coosje van Bruggen
2001.217

80. *Blueberry Pie Island*, 1998
Pencil and pastel, 30 x 38 3/4 (76.2 x 98.4)
Gift of the American Contemporary Art Foundation,
Leonard Lauder, Member 2002.66

81. *Notebook Page: Study for a Colossal Sculpture of a
Woman's Legs, Walking, for Michigan Avenue, Chicago*,
1994
Ballpoint pen and clipping, 11 x 8 1/2 (27.9 x 21.6)
Gift of Claes Oldenburg and Coosje van Bruggen
2001.210

82. *Notebook Page: Study for a Colossal Sculpture of a
Woman's Legs, Running*, 1994
Felt pen, pencil, watercolor, 8 1/2 x 5 3/8 (21.6 x 13.7), on
sheet 11 x 8 1/2 (27.9 x 21.6)
Gift of Claes Oldenburg and Coosje van Bruggen
2002.211

83. *Notebook Page: Variations on a Sculpture in the
Form of a Saw*, 1994
Pencil, four sheets, 5 x 2 3/4 (12.7 x 7) each, on sheet
11 x 8 1/2 (27.9 x 21.6)
Gift of Claes Oldenburg and Coosje van Bruggen
2001.218

84. *Notebook Page: Saw-Tie*, 1994
Pencil and watercolor, 8 9/16 x 5 7/16 (21.8 x 13.8), on
sheet 11 1/16 x 8 1/2 (28.1 x 21.6)
Gift of Claes Oldenburg and Coosje van Bruggen
2001.214

85. *Proposal for a Sculpture in the Form of a Saw,
Sawing*, 1994
Pencil, colored pencil, crayon, 40 x 30 (101.6 x 76.2)
Gift of LWG Family Partners, L.P. E.2001.366

86. *Notebook Page: Shuttlecock Sculpture Studies*, 1993
Pencil, colored pencil, watercolor, two sheets, 5 x 2 3/4
(12.7 x 7) and 2 3/4 x 5 (7 x 12.7), on sheet 11 x 8 1/2
(27.9 x 21.6)
Purchase, with funds from The Lauder Foundation,
Evelyn and Leonard Lauder Fund 99.52.4

87. *Notebook Page: Shuttlecock Sculpture Studies—
"Am Earheart"*, 1993
Pencil and colored pencil, two sheets, 2 3/4 x 4 7/8
(7 x 12.4) and 4 x 2 3/4 (10.2 x 7), on sheet 11 x 8 1/2
(27.9 x 21.6)
Purchase, with funds from the Drawing Committee
99.52.3

88. *Notebook Page: Soft Shuttlecock, One Feather
Elevated*, 1994
Pencil and colored pencil, 8 9/16 x 5 1/2 (21.7 x 14), on
sheet 11 x 8 1/2 (27.9 x 21.6)
Gift of Claes Oldenburg and Coosje van Bruggen
2001.212

89. *Notebook Page: Soft Shuttlecock, Spread on a Field*,
1994
Pencil and colored pencil, 8 7/16 x 10 1/8 (21.4 x 25.7), on
sheet 8 1/2 x 11 (21.6 x 27.9)
Gift of Claes Oldenburg and Coosje van Bruggen
2001.213

90. *Soft Shuttlecock, Raised*, 1994
Pencil and pastel, 39 3/16 x 27 1/2 (99.5 x 69.9)
Purchase, with funds from The Lauder Foundation,
Evelyn and Leonard Lauder Fund 99.52.2

91. *Soft Shuttlecocks, Falling, Number Two*, 1995
Pencil, pastel, charcoal, 27 1/4 x 39 1/4 (69.2 x 99.7)
Purchase, with funds from The Lauder Foundation,
Evelyn and Leonard Lauder Fund 99.51

92. *Dream Pin*, 1998
Pencil, colored pencil, pastel, 40 x 30 3/16 (101.6 x 76.7)
Gift of Claes Oldenburg and Coosje van Bruggen
2001.209

Drawings 2, 3, 8–10, 12, 13, 15–18, 20, 22–26, 28–44,
47–51, 53–68, 70, and 72 were formerly in the collection
of John and Kimiko Powers.

SELECTED DRAWINGS BIBLIOGRAPHY

Adriani, Götz, Dieter Koepplin, and Barbara Rose. *Zeichnungen von Claes Oldenburg* (exhibition catalogue). Basel: Kunstmuseum Basel, 1976.

Baro, Gene. *Claes Oldenburg: Drawings and Prints*. London and New York: Chelsea House Publishers, a Paul Bianchi Book, 1969.

Celant, Germano, Claes Oldenburg, and Coosje van Bruggen. *The Course of the Knife*. Milan: Editions Electa, 1986.

———. *A Bottle of Notes and Some Voyages* (exhibition catalogue). Sunderland, England: Northern Centre for Contemporary Art; Leeds, England: The Henry Moore Centre for the Study of Sculpture and Leeds City Art Galleries, 1988.

———. *Claes Oldenburg, Coosje van Bruggen* (exhibition catalogue). Milan: Skira Editore, 1999.

Eisler, Colin. *Sculptors' Drawings Over Six Centuries: 1400–1950*. New York: Agrinde Publications, 1981.

Johnson, Ellen H. *Claes Oldenburg*. Middlesex, England: Penguin Books, 1971.

Koepplin, Dieter, and Claes Oldenburg. *Claes Oldenburg: Die frühen Zeichnungen* (exhibition catalogue). Basel: Kupferstichkabinett der Öffentlichen Kunstsammlung Basel, 1992.

Morphet, Richard. *Claes Oldenburg: An Exhibition of Recent Erotic Fantasy Drawings* (exhibition catalogue). London: The Mayor Gallery, 1975.

Oldenburg, Claes. *Store Days: Documents from The Store (1961) and Ray Gun Theater (1962)*. New York: Something Else Press, 1967.

———. "Chronology of Drawings." *Studio International* 179 (June 1970): 249–53.

———. *Notes in Hand*. New York: Petersburg Press, 1971.

———. *Proposals for Monuments and Buildings 1965–69*. Chicago: Big Table Publishing Company, 1969, with an interview by Paul Carroll.

Oldenburg, Claes, and Coosje van Bruggen. *Sketches and Blottings Toward the European Desktop*. Florence: Hopeful Monster, 1990.

Rose, Barbara. *Claes Oldenburg* (exhibition catalogue). New York: The Museum of Modern Art, 1970.

Rose, Bernice. *Drawing Now* (exhibition catalogue). New York: The Museum of Modern Art, 1976.

Twentieth-Century American Drawing: Three Avant-Garde Generations (exhibition catalogue). New York: The Solomon R. Guggenheim Museum, 1976.

van Bruggen, Coosje. *Claes Oldenburg: Mouse Museum/Ray Gun Wing* (exhibition catalogue). Otterlo, the Netherlands: Rijksmuseum Kröller-Müller; Cologne: Museum Ludwig, 1979.

———. *Claes Oldenburg: Dibujos/Drawings 1959–1989* (exhibition catalogue). Valencia, Spain: IVAM, Centre Julio González, 1989.

———. *Claes Oldenburg: Nur ein anderer Raum* (Claes Oldenburg: Just Another Room). Frankfurt: Museum für Moderne Kunst, 1991.

———. *Down Liquidambar Lane: Sculpture in the Park*. Porto: Museu Serralves, 2002, with an essay by Richard Cork, and an interview with Coosje van Bruggen and Claes Oldenburg by Alexandre Malo.

Visionary Architects: Boullée, Ledoux, Lequeu (exhibition catalogue). Houston: University of St. Thomas, 1968.

221

ACKNOWLEDGMENTS

In 1999 the Drawing Committee of the Whitney Museum of American Art initiated a plan to extensively collect the drawings of Claes Oldenburg, thereby continuing a tradition, begun in 1997, of in-depth acquisition of the works of great living American draftsmen.

The goal was simply to create the most exceptional collection of Oldenburg drawings extant, from his tiny notebook sketches to his masterful finished monumental drawings.

Building on the four drawings already in the collection, the Whitney has since acquired eighty-eight drawings. This exhibition of ninety-two drawings includes seventy-four works by Claes Oldenburg and eighteen later works with his collaborator, Coosje van Bruggen, and describes the breadth of his career from 1959 to 1998. This collection will also provide an archival source for generations of students and art historians.

This group of works represents a beginning, rather than a conclusion, as the Museum's goal is to continue to build the collection with acquisitions of existing and future drawings.

First, I would like to thank the chairman, Leonard A. Lauder, who from the very first discussion understood, supported, and believed in the idea of a museum creating the most comprehensive collection of one of the twentieth century's greatest draftsmen. Alice Pratt Brown Director Maxwell L. Anderson has been unfailingly supportive and helpful throughout the project. The former chairs of the Museum's Drawing Committee, Murray H. Bring and Beth Rudin DeWoody, and all the committee members from 1999 to the present have nurtured and believed in this project.

This collection could never have developed without the generosity and graciousness of a few collectors who agreed to part with their drawings. I am particularly thankful to the late John Powers and Kimiko Powers, Richard Oldenburg, and Elizabeth Brooke Blake. I am also grateful to Anthony Grant of Anthony Grant Gallery and Arne Glimcher and Douglas Baxter of PaceGallery for their assistance in the acquisition of selected works.

Early in Oldenburg's career, three art historians, Ellen Johnson, Barbara Rose, and Gene Baro, wrote with perception and compassion about his art. I am deeply grateful for their profound and enlightened insights.

This publication has benefited immeasurably under the direction of Garrett White, Makiko Ushiba, Anita Duquette, Christine Knorr, Miranda Banks, and Susan Richmond.

There are many people who have assisted in different facets of the project. I am grateful to Sarah Buttrick, Mavis Morris, Sarah Wagner, Catherine Drake, Seth McCormick, and Anne M. Lampe, assistant curator at the Whitney. Jennifer Brennan, my assistant at the Whitney during the majority of the preparation for the catalogue and exhibition, was consistently enthusiastic, helpful, and patient, and I am most appreciative. Claes Oldenburg and Coosje van Bruggen's studio assistants Anu Vikram and Sara Greenberger were exceptionally helpful in coordinating various aspects of the catalogue and exhibition. My gratitude also goes to Donald Dellipaoli at Drummond Framing and the conservator Susan Schnitzer. In addition I would like to thank Jane Kramer for her insightful observations.

Claes Oldenburg and Coosje van Bruggen have gone far beyond being helpful, supportive, and patient with this project. They have added greatly to our understanding both of the early drawings and of the exciting process by which they collaborate to create drawings of their projects. They have also been most generous in their exceptional gifts of drawings to the Whitney Museum, and I am most grateful.

Janie C. Lee
Curator, Drawings